Landscapes of the
PICOS DE
EUROPA

a countryside guide

Teresa Farino

SUNFLOWER
BOOKS

First published 1996
by Sunflower Books
12 Kendrick Mews
London SW7 3HG, UK

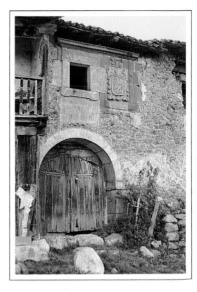

ISBN 1-85691-069-5

Important note to the reader

We have tried to ensure that the descriptions and maps in this book
are error-free at press date. The book will be updated, where neces-
sary, whenever future printings permit. It will be very helpful for us to
receive your comments (sent in care of the publishers, please) for the
updating of future printings.

We also rely on those who use this book — especially walkers —
to take along a good supply of common sense when they explore.
Conditions change fairly rapidly in the Picos de Europa, and *storm
damage or bulldozing may make a route unsafe at any time*. If the
route is not as we outline it here, and your way ahead is not secure,
return to the point of departure. *Never attempt to complete a tour or
walk under hazardous conditions!* Please read carefully the country
code on page 46, the general walking notes on pages 36-45, and the
introductory comments for any excursions you take (regarding road
conditions, equipment, grade, distances and time, etc). Explore *safely*,
while at the same time respecting the countryside and its inhabitants.

Cover photograph: Beges, at the foot of Andara
Title page: Marbled whites are among the commonest butterflies in the
range.
Above: Pantiled roofs and coats of arms carved from huge blocks of
stone add to the charm of the villages, as here in Colio

Photographs by the author
Touring map by John Theasby and Pat Underwood; walking maps
adapted by Pat Underwood from 1:50,000 Spanish Military maps
(with kind permission of the Servicio Geográfico del Ejército)
A CIP catalogue record for this book is available from the British Library
Printed and bound in the UK by Brightsea Press, Exeter

10 9 8 7 6 5 4 3

 # Contents

4 Landscapes of the Picos de Europa

Flora and fauna illustrated in this book

❂ Preface

Twelve years ago, when I first heard the words 'Picos de Europa', I had no idea what or where such a locality might be. Then, during a University field trip in 1985, I fell in love with this diminutive mountain area to such an extent that I gave up a permanent job in England and came back to live here. Today I eke out a precarious existence as an environmental journalist and leader of wildlife excursions; a lifestyle which is more than compensated for by the incredible diversity of plant and animal life which inhabits the Picos de Europa.

The Picos de Europa are the high point of a long ridge of mountains which runs along the north coast of Spain, the Cordillera Cantábrica. Ranging in altitude from 150m to 2648m (about 500-8700ft), the Picos are divided into three spectacular limestone massifs: Cornión in the west, Urrieles in the centre and Andara in the east. These are separated from one another, and from the surrounding ranges, by precipitous gorges, carved out over millennia by some of the southernmost salmon rivers in Europe.

The scenery is spectacular: wherever you are, jagged peaks dominate every horizon. The highest forests are composed mainly of beech, giving way to mixed woodlands of Pyrenean oak, ash, sweet chestnut and lime lower down, while in the hotter, drier parts of the Picos, the forests are composed of drought-tolerant evergreen species such as holm and cork oaks, with a luxuriant understorey of shrubs more usually associated with Mediterranean habitats.

It is thought that this part of Spain has been colonised by man for around 25,000 years, following the discovery of a large number of caves housing Palaeolithic paintings. But it was not until about 5000 years ago that man started to change his environment, gradually clearing the extensive forests to provide grazing land for his newly-domesticated livestock, creating a mosaic of tiny pantile-roofed villages, meadows and woodlands. The antiquity of these grasslands has resulted in a diversity of plantlife unrivalled in western Europe today: for me this is perhaps the most attractive feature of the Picos de Europa.

Beef is the basis of the local economy, and a centuries-old cyclical system still persists today: the sole inputs are energy from the sun and human labour, while the 'harvest' is a crop of young stock for sale at the autumn *ferias*. During the summer, the cattle are taken up to the natural pastures which occur in the high mountains, freeing the meadows in the valley bottoms for the production of hay. At the onset of the first snows, the cattle return to the valleys, where they spend the winter in barns in the villages, munching their way through piles of sweet-smelling dried grass. The manure which accumulates during this period is spread on the meadows in the spring, thus replenishing the nutrients and ensuring a good crop of hay the following year.

The rugged terrain has meant that twentieth-century technology has been slow to affect the Picos de Europa: even now, many farmers still scythe their meadows by hand, eschewing modern machinery, as well as artificial pesticides and fertilizers. Ancient breeds of cattle, particularly adapted to a high mountain environment, are still widely used today, particularly the small, red *casina* in Asturias (see photograph page 115) and the wide-horned, grey-roan *tudanca* in Cantabria.

Over the past decade the Picos de Europa have gradually been discovered by the outside world, and today these mountains are renowned all over Europe for their spectacular mountain scenery, abundance of wild-life and the traditional way of life practised by their human inhabitants. Part of the attraction, for me at least, is a determined resistance to outside technology, such that life here goes on in much the same way as it has for centuries — man in harmony with his environment.

As a mountain area gains in popularity, a surfeit of guides tends to appear on the shelves of bookshops across Europe. In the case of the Picos de Europa, however, little has been written in any language, except for a handful of serious mountaineering tomes. This book will, I hope, appeal to people like myself, with a love of mountain landscapes and their wildlife, but a marked aversion to 1500m/5000ft ascents on foot!

Much of the sheer grandeur of the Picos de Europa can be experienced from a car, but it is not until you start to explore on foot that many of the more memorable qualities of these mountains come to light. For example, there is little to beat being literally at arm's length from soaring griffon vultures as you ascend to the

isolated montane village of Tresviso ... marvelling at the wealth of wildflowers and butterflies which inhabit the meadows between Pido and Fuente Dé ... encountering endemic alpine flora in the almost lunar landscape of the Vega de Ario ... or wandering through the unique cork oak forests of Tolibes, accompanied by the furtive movements of half a dozen different species of lizard.

Come and discover the marvels of the Picos de Europa for yourselves!

Acknowledgements

I would like to express my gratitude to the following people, all of whom dedicated considerable time and effort to assisting me with the logistics of writing this book:

Ramón Alvarez Valle and family, for their collaboration in Onís.

Luis Fernando Monje Roiz, for timely vehicle support.

Javier García-Oliva Mascarós, for useful discussion and transport in Liébana.

Adrian Garlick, for sharing his knowledge of Cabrales with me.

Oscar Sánchez Corral, for revealing to me some of the best-kept secrets of Andara.

Robin Walker, for his invaluable help with the Asturian section.

My editor, Pat Underwood, for her continual encouragement and sympathetic ear.

And finally, very special thanks to Mike Stuart and Lisa Medland, at the Casa Gustavo Guesthouse, for their boundless hospitality — particularly for making sure that I ate from time to time! —. and for always being available when I needed a helping hand.

Useful books

Very little has been published about the Picos de Europa in any language, but the following may be useful if you read Spanish:

Argüelles, M et al (1981) *Naturaleza y Vida en los Picos de Europa*. Incafo, Madrid.

Cendrero Uceda, A et al (1986) *Guía de la Naturaleza de Cantabria*. Ediciones de Librería Estudio, Santander.

Enríquez de Salamanca y Navarro, C (1985) *Por los Picos de Europa (de ándara al cornión)*. Las Rozas, Madrid.

Luceño, M and Vargas, P (1995) *Guía Botánica de los Picos de Europa*. Piramide. A photographic guide to the flora, in colour.

Rico, E et al (1987) *Guía del Parque Nacional de la Montaña de Covadonga*. Silverio Cañada, Gijón.

Field guides in English

Polunin, O and Smythies, B E (1973) *Flowers of South-West Europe — a field guide*. Cambridge University Press. The most complete guide in a single volume.

Grey-Wilson, C and Blamey, M (1979) *The Alpine Flowers of Britain and Europe*. Collins, London. For the alpine flora.

Schönfelder, I and Schönfelder, P (1984) *Photoguide to the Wild Flowers of the Mediterranean*. Collins, London. For the Liébana flora.

Heinzel, H et al (1979) *The Birds of Britain and Europe*. Collins, London.

Getting about

Getting about on public transport in the Picos de Europa is a bit of a nightmare, as there is no train service and the buses are aimed primarily at the needs of local people, travelling from the villages to the main towns in the morning, and back again last thing at night. In addition, transport between the three main valleys in the Picos — Liébana, Cabrales and Valdeón — is nigh on impossible, as they lie in three different provinces. Nevertheless, I have tried to link most walks with the existing bus routes. A word of caution: *always* put your hand out to stop a bus, even if you are standing at a recognised bus stop.

In terms of **local buses**, the company which operates in Liébana is called PALOMERA (Tel. 942-88 11 06). The buses are not numbered, and may be difficult to distinguish from tour coaches: look out for the cream livery with green side stripes. The PALOMERA service links Potes with Santander (the capital of Cantabria) via the Desfiladero de La Hermida, stopping at every road-side village between Potes and Panes. Buses leave Potes for Santander every day at 07.00, 09.45 and 05.45 all year round, departing from the bar called La Caseta, at the western end of the town.

PALOMERA also runs buses from Potes to the cable car station at Fuente Dé, primarily in the summer (1 July to mid-September), leaving Potes at 08.15 (09.00 on Sundays and feast days), 13.00 and 20.00, and returning from the Hotel El Rebeco in Fuente Dé at 09.00 (09.45), 17.00 and 20.45. Outside these dates, between Easter and November, a bus leaves Potes at 13.00 and returns from Fuente Dé at 17.00. Basically you can get on or off this bus at any village which lies on this route.

In addition, a company called EMPRESA FERNANDEZ (Tel 987-22 62 00), runs from Santander to León during the summer, which is the only means of public transport available for Walk 5: the bus (silver livery) leaves Potes for Puerto de San Glorio at 10.00, departing from the Hostal Picos de Europa.

In the northern reaches of the Picos de Europa, public transport is monopolised by a company called ALSA: again the buses are not numbered, but the livery is blue

and silver. There is a comprehensive all-year-round service linking Panes with Cangas de Onís, via Arenas de Cabrales. In the summer, buses also link Arenas with Puente Poncebos (useful for Walks 7 and 8): there are departures from Arenas at 10.00 and 18.00, with return buses at 10.15 and 18.15. ALSA also runs a fairly frequent service from Cangas to Covadonga and, in the summer, some of these buses continue on up to the glacial lakes in the National Park. Contact their Cangas de Onís office on 98-584 81 33 for details.

Taxis are relatively cheap throughout the Picos, and some of the walks described in this book will require the use of this means of transport. It is wise to check the fare *before* setting out.

By now it is probably obvious that a **car** is the best means of transport for such a rural area, and many people opt to bring their own vehicles to Spain via the ferries from Britain (P&O from Portsmouth to Bilbao, or Brittany Ferries from Portsmouth/Plymouth to Santander). The nearest town to the Picos de Europa where hire cars are available is Llanes (on the Asturian coast), although lower prices can be obtained in the nearby cities: Santander, Oviedo or León. The advantage of having your own transport for exploring the more remote valleys in the Picos de Europa — and for getting to the walks — is incalculable.

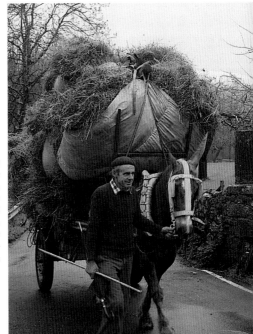

Modern transport has passed by many of the farmers in the Picos, who still carry on a timeless way of life. Here an Asturian farmer leads his horse and hay-cart.

✿ Picnicking

In such a rural area as the Picos de Europa, the opportunities for 'freelance' picnicking are virtually endless, while formal facilities are few and far between, and tend to be limited to unattractive roadside areas. I have included only a few of the more spectacular picnic sites in the following two pages, all of them easily accessible in the course of the car tour and demanding a walk of no more than 30-35 minutes at most.

The location of all these picnic settings is indicated on the *touring map* by the symbol **P**. (A few picnics are also highlighted on the relevant *walking maps*.) Please remember to **wear sensible shoes and take a sunhat** (the symbol ○ after the title indicates a picnic **in full sun**). It's

PICNIC FOOD — *SPECIALITIES OF THE PICOS DE EUROPA*
Picnickers in the Picos are spoilt for choice in terms of the delicious local produce available. **Cheeses** are a real speciality, with almost every village producing its own variety. In the southern valleys of Liébana, the many artisan cheeses have recently obtained a blanket denomination of origin, under the heading *quesucos de Liébana*. Particularly worth trying are Río Deva, from Camaleño, which is a creamy cows'-milk cheese, and the varied produce from the Peña Remoña dairy in Pido, especially the fresh goats'-milk cheese, which is delicious with *membrillo* (quince jelly).

The most renowned cheese of the region, however, is *queso picón*, a smooth blue cheese, classically produced from a mixture of cows'-, sheep's- and goats'-milk, in the remote mountain villages of Beges and Tresviso: it always comes away with the top prizes in the Barcelona cheese festival, and also has denomination of origin status.

Very similar to *picón* is *cabrales*, produced in the Asturian villages of the region of the same name, on the northern flanks of the Picos, while a more commercial, but equally tasty product comes from the Posada de Valdeón dairy 'Picos de Europa'; you might also like to try their blue cheese 'paté', sold in Kilner jars.

If you're not a cheese fan, maybe the locally produced **hams** and **sausages** will tempt you. Air-cured hams, sliced wafer-thin, are particularly mouth-watering, although they may be something of an acquired taste: *jamón serrano* is the local variety, but you will notice the difference in flavour if you try the more expensive *jamón ibérico*, produced from the black *pata negra* pigs of southwestern Spain, which are free-range and fattened on acorns.

Almost every region of Spain has its own distinctive method of making *chorizos* — the spicy, cured pork salamis which are so delicious either raw or cooked — and I find the northern Spanish ones particularly tasty. The best *chorizos* are always home-produced, but

a good idea to take along a plastic groundsheet as well, in case it's damp or prickly.

1 COLLADO DE LLESBA (touring map and map page 74, photograph page 12) ○

by car or taxi: 35min on foot *by bus: 35min on foot*
🚗 at the Puerto de San Glorio (see Car tour, page 24)
🚌 EMPRESA FERNANDEZ (Tel. 987-22 62 00; Santander-León route); ask to be set down at Puerto de San Glorio.
Follow Walk 5 (page 73) for 35min, until you reach the col at Llesba. Best to avoid weekends and public holidays. Pick a fine day for this picnic, otherwise the magnificent panorama of the central and eastern massifs of the Picos will be concealed by cloud. No shade.

2 LAGO DE LA ERCINA (touring map and map pages 120-121, photograph pages 122-123) ○

by car or taxi: 10-20min on foot *by bus: 10-20min on foot*
🚗 at the car park by the Lago de la Ercina (see Detour 2, page 32)
🚌 ALSA (Tel. 98-584 81 33) to Los Lagos de Covadonga, at the end of the route from Cangas de Onís to the lakes in the Covadonga National Park (summer only)

unfortunately EU legislation prevents their sale to the public, so you'll have to make do with the local butchers' varieties.

Most of these cheeses and meat products are available from any supermarket, no matter how small, as they are widely eaten by the local people. Lower prices, however, can be obtained by buying direct from the producers, at the **weekly markets**. Potes, the capital of Liébana, celebrates its markets on Mondays, and Cangas de Onís on Sundays (beware trying to buy *anything* in Cangas on a Monday, as all the shops are shut ... and the banks too). Both markets are in progress from about 10am to 2pm.

The **bread** in Liébana and Valdeón is far superior to that in Asturias, mainly because the bakeries are still wood-fired in these southern valleys. Bakers' shops, however, are few and far between: most bakeries deliver to the many villages around the valleys on set days each week, but you can buy direct (there is one bakery in Posada de Valdeón and several in Potes), or from the supermarket.

Supermarket hours are from about 10am to 2pm, then about 4.30pm to 8pm, but they usually run out of fresh bread by the afternoon. Many villages have bars which double as shops, which are open at all hours (from about 8am to 11pm or later), but are usually a bit more expensive.

A word about **alcoholic specialities!** Asturias is renowned for its scrumpy-like cider (*sidra*), a small quantity of which is poured from a great height into a large, finely-blown glass, to be drunk immediately, before it loses its 'fizz'. Liébana is famed for its *orujo* or *aguardiente,* distilled from the skins and pips of grapes left over from wine-making. Similar to Italian *grappa*, the neat version is 50° proof and takes the back out of your throat, but nowadays less formidable varieties are on offer, flavoured with herbs, honey or fruits. Liébana is also home to a very sweet aperitif wine called *tostadillo*, but if you prefer something a bit drier before your meal, try a *blanco de solera,* which is a cross between white wine and *fino* sherry.

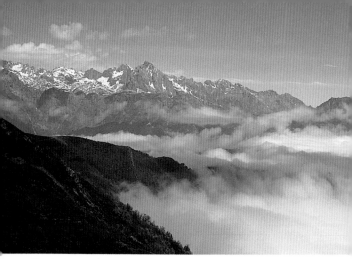

Picnic 1: view from the Collado de Llesba; Cantabria's highest mountain, Peña Vieja (2613m/8570ft), rises in the background.

Walk as far as you like around the shores of the attractive glacial lake and picnic on the short, springy sward, with magnificent views in all directions. Avoid weekends and public holidays — including Mondays in high summer, when the shops and banks are closed in Cangas de Onís, and the local people head for the hills. Very little shade.

3 MIRADOR DE PIEDRASHITAS (touring map)

by car or taxi: 30min on foot *no access by bus*
🚗 park at the Puerto de Panderruedas (see Car tour, page 26)
Take the track heading due north from the col, which leads up through the beech forest to a stone-built viewpoint with a magnificent panorama over the Valdeón valley and the central massif of the Picos de Europa. Shade in the beech forest.

4 EL CABLE (touring map and map pages 82-83, photographs pages 80, 84, 86) ○

by car or taxi: 10-15min on foot *by bus: 10-15min on foot*
🚗 park at the cable car station at Fuente Dé (see Detour 4, page 34)
🚌 PALOMERA (Tel. 942-88 11 06) from Potes to Fuente Dé
Take the cable car from Fuente Dé up to 1800m/5900ft and walk in any direction until you have left the crowds behind, to picnic amongst the alpine flowers in the limestone rock gardens. If you are lucky, you might even persuade some alpine choughs to share your meal with you, as they are notorious scroungers and relatively unafraid of man! Avoid July and August and weekends throughout the year. No shade.

5 ARROYO DE MOSTAJAL (touring map) ○

by car or taxi: 10-15min on foot *no access by bus*
🚗 park on the bridge which crosses the Río Yuso at the point where its two main tributaries (the Arroyo de Mostajal and the Valle de Puerman) join: the bridge lies on a sharp hairpin bend between Portilla de la Reina and the Puerto de Pandetrave (see Car tour, page 26).
Walk northwest from the bridge and picnic in the lush meadows by the clear waters of the Arroyo de Mostajal. The wealth of wildflowers here is almost unbelievable. No shade.

12

✹ Short walks

The following six *very short, easy walks for motorists* have all been keyed into the Car tour. Instructions for access are given according to the direction of travel in the tour, but you should find the departure points easily, even if you are not following the tour precisely — look for the 🚗 symbol on the *car touring map*, followed by the appropriate number. The maximum length of these walks is 7km/4.4mi, and climbing has been kept to a minimum. Since the routes are easy to follow, no maps accompany the notes. All the routes are linear (except for No 6), so you can shorten the walks even further by turning back at any point. **Appropriate equipment** for all these walks is the same: stout shoes, sunhat, cardigan, raingear, picnic and water.

🚗1 VALLE DEL NARANCO (photograph pages 14-15)

7km/4.4mi; 1h55min. A gentle climb of about 180m/590ft, and descent of the same. Much of the route is over 1500m/4920ft, and may be snowbound from November to May.
🚗 *Park by Mesón Llánaves, in the village of Llánaves de la Reina, on the N621 (the 32km-point on the Car tour, page 25)*
The Valle del Naranco has an almost Swiss mountain flavour about it, especially in winter, when the imposing snow-covered peaks contrast strongly with the pines that have been planted on the lower slopes. In summer it's a great place for a picnic, surrounded by the murmur of myriad bubbling streams and the gentle lowing of contented cattle.

Start the walk by heading east along the N621, passing the petrol station on the right. When the road veers sharp left, keep right (more or less straight ahead) over a bridge. You cross the Arroyo del Valle, to walk parallel with another watercourse (the Arroyo del Naranco) down on your right. There is a footpath sign on the left here, 'Senda Valle del Naranco y Valle de la Lechada'. You will follow this gravelly 4WD track all the way to a hut owned by the Santander Mountaineering Club, the Refugio del Tajahierro.

In **10min** ignore a track forking right downhill to the meadows on the far side of the stream, and, 10 minutes later, ignore another wide path turning off to the right. At about **55min** the track veers right and you cross a stream coming down from the Boquerón de Tarna on the left. The refuge is clearly visible ahead now, sitting

in the middle of a wide grassy valley against a backdrop of impressive peaks. You reach it at **1h10min**.

Return the same way (**1h55min**).

🚌2 MIRADOR DEL TOMBO (nearby photograph page 30-31)

6km/3.75mi; 1h40min. An undulating descent of about 170m/560ft, with a return climb of the same. Possible all year round, except after exceptionally heavy winter snows.
🚌 *Park near the centre of Posada de Valdeón (the 56.5km-point in the Car tour, page 26), on the road heading southwest towards the Puerto de Panderruedas (LE244).*
This route takes you through superb dry haymeadows down to the Mirador del Tombo, a renowned viewpoint for the upper Cares valley, with a spectacular panorama of the western and central massifs of the Picos. Early summer is perhaps the best time to do this walk, when the English irises, round-headed leeks, sawfly, man and fly orchids, and other rare grassland wildflowers are at their colourful best.

Start the walk by heading towards the town hall (flags over the entrance) on the right-hand side of the road just as you leave Posada on the LE244. Just *before* this building, turn right down the Calle del Salvador towards an *hórreo* (grain store), which you leave on your right. Follow the lane past the Hostal Abascal, on the left, then ignore a turn-off to the left and one to the right. Shortly you come to two *hórreos* on the left, and the road forks: take the left-hand branch, crossing the Río Cares.

Beyond the bridge turn right, parallel with the river, and follow this earthen track until you come to a house on the right (**10min**), where the track forks: keep right, passing a building with a corrugated iron roof down to the right a minute later. Shortly the small reservoir

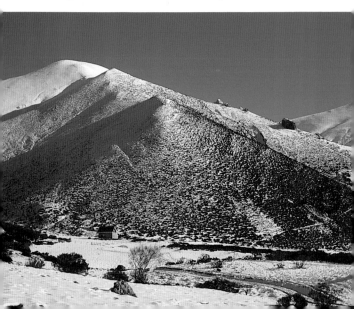

which serves the hydroelectric station comes into view: this was built in the early 1990s and caused considerable outrage on environmental grounds, although it is already attracting grey herons and mallard in winter. On meeting a tarmac road (**15min**), turn left. The asphalt disappears immediately, and the track forks: keep right. *Take note of this point for your return.* (The left fork leads to the cemetery, which is of the 'honeycomb' variety, as the soil is too shallow for the digging of graves.) A couple of minutes later the track takes you above the dam of the hydroelectric station. There is a superb view down the valley from here, with the peaks of the central massif on your right providing a perfect backdrop for the terraced meadows on the margins of the Río Cares.

From here on you pass through these meadows, rich in wildflowers, descending gradually. *Keep right at all forks you encounter.* Soon Cordiñanes comes into view ahead, on the far side of the valley. Continue until you have passed the village (**30min**), at which point the track bends sharp right and descends to the Posada-Caín road. Turn left and follow the road down to the Mirador del Tombo (**40min**), marked by a statue of a chamois.

To return to Posada, you could stay on this narrow road. It is little used except in high summer and offers a fine view of the peaks of the western massif up on your right. It also has the advantage of passing through Cordiñanes, which boasts several bars. Alternatively, retrace your steps to the 15min-point in the walk, then

follow the tarmac road across the Cares, returning to Posada via the village of Los Llanos. Having crossed the bridge, follow the tarmac as it curves round to the left, past an *hórreo* on the right, and arrive at a T-junction in the middle of the houses, where the tarmac gives way to concrete. Turn left here, and leave a large stone house with a cylindrical bread oven on its outside wall on your right, then follow the concrete as it veers right, back to the Caín-Posada road (**1h30min**). Turn right and follow the road back to your car in the centre of Posada de Valdeón (**1h40min**).

December: approaching the Refugio del Tajahierro in the Valle del Naranco (Short walk 1 for motorists)

🚗3 RIO CASAÑO AND THE LA MOLINA GORGE (photo page 126)

*5km/3mi; 1h30min. A short descent of 50m/165ft, followed by a gra-
dual undulating ascent of 100m/330ft, and vice versa on the return.
Possible all year round. Add **swimwear** to the equipment list.*

🚗 Turn right (southwest) off the C6312 at Canales de Cabrales (the
138.5km-point on the Car tour, page 27), signposted 'La Molina'. Park
2km downhill just *before* the turning circle at the entrance to La
Molina (no parking is allowed in the turning circle).

*This is a great walk for a hot summer's day, as this stretch of the Río
Casaño is one of the best places to swim in the whole of the Picos, as
well as providing some shady picnic spots amongst groves of ancient
sweet chestnuts.*

Start out by following the concrete road that continues
from the far side of the turning circle. Keep bearing
right, so that *all* of the houses are down to your left;
ignore all side-turnings down to the village. Soon the
road descends quite steeply, crosses a small stream, and
then forks. Go right here, out of the village, past the last
two buildings (on your right). Now the concrete road
narrows to a cobbled trail and drops sharply down to a
small arched bridge (Puente Pompedro; **15min**). *Don't*
cross this bridge; keep right, to cross a *second* stone
bridge; it takes you over the Casaño which seethes
noisily in a rock cauldron far below you at this point.

Follow the trail — in places little more than a path —
parallel with the river, which is now on your right.
Several swimming holes lie along this stretch — one
even has a narrow gravel beach. By **30min** you will spot

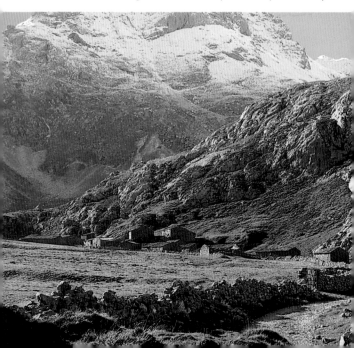

a small group of barns on the far side of the river, and the ruins of an old hydroelectric station straight ahead.

Before you reach the ruins, your trail swings right over a narrow wooden bridge (Puente Escobín), which is partially concealed from view behind a limestone outcrop. Having crossed the river, keep left and follow the river upstream, ignoring a fork off to the right. Soon you pass another group of buildings on your left (photograph page 126). The trail narrows to an earthen path and you arrive at a third bridge (Puente Los Mineros; **45min**). A superb swimming spot lies just upstream, where you can dry off on smooth rocks.

Return the same way (**1h30min**).

⛟4 VEGAS DE SOTRES (photograph below and page 33, bottom)

6km/3.75mi; 1h45min. A short descent of 50m/165ft, followed by a gentle climb of 170m/560ft, and vice versa on the return. May be snowbound between November and May.

⛟ Turn off right (south) at the hairpin bend about 1km before the village of Sotres (the 19km-point on Detour 3 of the Car tour, page 33). Park immediately, on the right-hand side of this wide track.

A lovely walk along the Río Duje valley, to the majadas *known as the* Vegas de Sotres, *in the heart of the Picos. The mountain scenery is spectacular, and the limestone rock-gardens beside the track are teeming with flowers in spring and summer. Look, too, for the peregrine falcons that nest in the crags above the Vegas de Sotres.*

Start out by heading due south along the wide gravel track on which you parked. It drops down to cross the

Río Cabau before climbing up above the Invernales del Texu down on your right. After about **10min** keep straight ahead, when a major track forks off to the right downhill. Now just follow the track all the way to the Vegas de Sotres (**1h**), crossing the crystal clear waters of the Duje just before you arrive. In summer, you can quench your thirst at a very rustic bar — in the middle of the *majadas,* on the right-hand side of the track.

Return to your car the same way (**1h45min**).

Vegas de Sotres from the north

🚌5 LA SENDA DE CICERA

5km/3mi; 2h10min. More of a challenge, this walk ranges from easy to moderate, with an ascent of 350m/1150ft on an old trail, followed by the same descent. Possible all year round.

🚌 *Park by the bus shelter located between the marker posts KM160 and KM159 on the N621 (the 186.5km-point on the Car tour, about 4.5km south of La Hermida; see page 29). It is not possible to enter this parking space from the south, because of a blind bend.*

This walk follows an ancient trail which links the Desfiladero de La Hermida with the village of Cicera. The route has the dramatic 'feel' of Walks 3, 7 and 8, but is shorter, less strenuous, and much less vertiginous. It follows the Riega Cicera as it cascades down from the heights of Peñarrubia to join the Río Deva.

Start out by walking south along the N621 for about 40m/yds, crossing the bridge which spans the Riega Cicera where it enters the Deva. Then turn left immediately on a small path which heads uphill parallel with the stream. (The first 20m/yds or so may be rather overgrown, but the path soon becomes more obvious and drops down to river level.) On your right is a sheer wall of almost-white limestone populated by red valerian, livelong saxifrage and leafless-stemmed globularia. After **5min** the path widens and becomes more trail-like, climbing away from the river down on the left. A few minutes later you pass a deep shaft in the limestone on your right, the bottom of which is unfathomable. The river drops in a series of waterfalls, and the trail steepens to keep pace. A zigzag to the right (**15min**) is followed shortly by another to the left, taking you back parallel with the *riega,* but well above it. From here the trail undulates for almost 1km and you start to see trees, including small-leaved lime, English oak and holm oak.

At **45min** pass a vertical slab of rock engraved with a cross on the right of the trail, the significance of which escapes me. Make sure you take the *right-hand* fork here (the left branch, which heads riverwards, is obviously abandoned). Now the rock starts to change from limestone to acid shales and sandstones; Pyrenean oaks appear, distinguished by the furry 'peach-skin' undersides of the leaves. A steep section, paved with rounded sandstone cobbles and negotiated by a sharp right-left zigzag, takes you up onto the level, where the trail deteriorates into a path somewhat overgrown with gorse.

By **1h10min** the path has widened out again, and you can see Cicera ahead. Pass an old stone shrine on the right and, a few minutes later, cross a tributary of the Riega Cicera. When the trail forks, keep right (the left fork goes to an old mill-house on the stream). Shortly a

track joins from the left, and you keep right (more or less straight on). Your trail has now become a track. Just before the first houses, cross the river on a modern bridge, with another mill-house on the right, in the base of which you can still see the mechanism.

It is worth looking around Cicera (**1h20min**), as most of the houses are built from huge blocks of well-worked stone and several have coats of arms. The church dates from the 18th century. The only pity is that neither of the bars is still in business. Retrace your steps to the La Hermida Gorge, taking care on the upper sandstone section, as the smooth rounded cobbles on the trail can be very slippery in wet weather (**2h10min**).

⛩6 PALACIOS OF THE BEDOYA VALLEY

5km/3mi; 1h35min. An easy climb along the road of 120m/395ft, followed by a descent of about 200m/650ft, then a short ascent of 80m/260ft to complete the circuit. Possible all year round.
⛩ Turn left (east) off the N621 about 200m north of Tama (the 195km-point on the Car tour, page 29). Drive up to San Pedro de Bedoya (4km) via the village of Esanos (ignore left turns to Trillayo, Cobeña and Pumareña). In San Pedro, park on the right, opposite a long water trough (just where a tarmac road — your walking route — veers left).
The Bedoya valley, nestling in the elbow created by the abrupt lime-stone crags of Peña Ventosa to the north and the long ridge of Peña Sagra to the east, is one of Liébana's best-kept secrets. Its south- and west-facing slopes are chequered with vineyards, from which the local people produce an acid wine (which luckily never reaches the open market!) and the potent spirit known as orujo. A particular feature of this valley is that almost every tiny village boasts a large, ornate manor house, here called palacios. As this walk is a bit more complicated than the others, a map is included below.

The walk begins by following the tarmac road which heads left out of the centre of San Pedro for Salarzón (indicated by a fallen-down sign). Climbing gently, accompanied by views of the eastern massif of the Picos ahead and Peña Sagra behind, you arrive in Salarzón

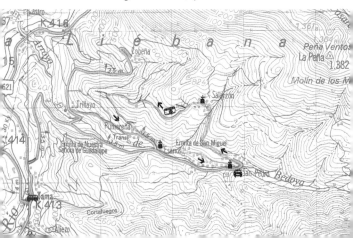

(**30min**). The Palacio de los Gómez de la Cortina is clearly visible in the centre, distinguished by four arches on the ground floor and a large stone coat of arms dating from 1823. The tarmac gives way to concrete as you enter the village, and you follow the narrow main street round to the left, leaving the church on the right. This church is one of Cantabria's very few examples of neoclassical architecture, with an interesting octagonal tower and a porch supported by Tuscan-style columns.

Where the concrete bends sharply right, just after the church, take the earthen track that leads straight on, past a *potro* (for shoeing cows) on the left. This brings you to a T-junction, where you turn left and leave the village behind; the last house, on your right, is the abandoned school, still complete with desks and blackboard. Follow this narrow earthen track as it contours around the hillside through dry meadows and copses of Pyrenean oak; ignore a turn-off to the right after a couple of minutes, and another one a minute or so later.

As the track veers right, a phenomenal panorama opens out before you, with the Picos to the right and the Cordillera Cantábrica to the left. As the track starts to descend, you find yourself walking down the crest of a west-facing spur. At about **45min** ignore a track turning off sharply back to the right, followed almost immediately by a fork off to the left (which you also ignore). Pass a barn in the meadows on the left, and ignore a path off right. You are now in Pyrenean oak forest, and the highest part of the spur is slightly to your left. Pass another turn-off to the right, then emerge from the forest a few minutes later: in front of you is the col known as Pelea, which is crossed in Walk 2, with the sheer wall of Agero to the right of it.

Watch for a fork in the track (just under **55min**): take the *left-hand* branch, bending back sharply to the southeast. A minute later, meet a track coming in from the right and turn left along it. You descend gently back into the Bedoya valley, through a mosaic of vineyards, dry pastures and greenweed scrub, dotted with Monterey pines. Within 10 minutes the roofs of Pumareña come into view, and your track veers right downhill towards them. Ignore a track which goes straight on up the hill.

Arrive at the first houses of Pumareña in **1h05min** and at a T-junction a couple of

minutes later. Turn right downhill, coming on to a concrete road in just 25m/yds. Turn left down through the village, leaving a large *casa señorial* (protected by a small shrine to the Virgin on the wall by the gate) on your right. Keep following this concrete road down towards the bottom of the valley, passing a few isolated houses, until you arrive at the *bolera* (skittles arena) on the left, and the Ermita de San Miguel immediately afterwards, also on the left.

At **1h15min** come to the point where the road crosses the river to rejoin the main road: *do not cross the bridge.* Turn left up a track (there are walled vegetable patches on the right). A minute later, cross a small stream, and keep following the track as it climbs gently into Esanos. At the first houses concrete comes underfoot (**1h20min**). The concrete road forks almost immediately, and you take the left-hand branch, leaving the bulk of the village down on your right. Ignore all the side turnings which give access to the houses and keep straight on.

Soon the bell-tower of the 17th-century church of San Pedro comes into view ahead. Make your way towards it, leaving all buildings on your right. Five minutes later, ignore a fork which leads onto the main road to the right, and keep climbing gently until you pass to the left of the church. Almost at once, come to a cherry tree in the middle of a crossroads: bear right here and follow the lane past the magnificent Palacio de los Ceballos on your right, with its own private chapel. Come to a T-junction a minute later and turn right, emerging by the water trough at the start of the walk (**1h35min**).

 # Touring

The Picos de Europa, for all their grandeur, cover a remarkably small area — only some 40 kilometres across and 20 kilometres from north to south (25 by 13 miles). But the terrain is so abrupt that there are no roads through the centre of these mountains, and the only possible touring circuit is a route around the edge of the Picos, with periodic excursions up into the heartland.

The route described on pages 24-35 is *the* classic car tour in the whole of the Cordillera Cantábrica. Although the main circuit is less than 200km, the roads are unbelievably tortuous, given that you have to cross four mountain passes and negotiate the two extensive limestone gorges which separate the Picos from the adjacent ranges. It is just about possible to complete the circuit and the four detours on a long summer's day, but *a more relaxed, two-day tour is by far the better option*.

I have described the car tour starting from Potes, the market town which lies at the centre of Liébana, in the

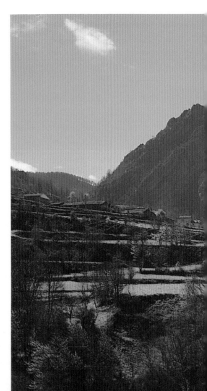

Terraced haymeadows at the foot of Pica Ten, near Oseja de Sajambre. The plant diversity of these grasslands is incredible, owing to the lack of pesticides and artificial fertilisers, and a centuries-old system of management.

southeastern corner of the Picos. A possible overnight stop would be in Cangas de Onís, situated at the opposite corner of these mountains, or in Cabrales (Arenas or Carreña) on the northern edge of the range. All three towns offer a wide choice of accommodation.

The touring notes are brief: they include little history or information that can be found in pamphlets available from the tourist offices. Instead I concentrate on the 'logistics' of touring: times and distances, road conditions, and taking you to the most interesting sights — and the places to which I hope you will return to **walk**. Only on foot can you make the most of the Picos de Europa.

The large fold-out touring map is designed to be held out opposite the touring notes. Symbols used in the text are explained in the map key.

Take along **warm clothing**, **food** and **drink**; you may experience delays. **Allow ample time for stops:** the estimated driving times, both for the main tour and the detours, include only short breaks at viewpoints labelled ⏍ in the notes.

All motorists should read the country code on page 46 and go quietly in the countryside. *Buen viaje!*

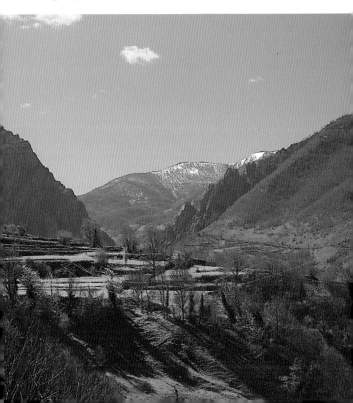

HIDDEN SECRETS OF THE PICOS DE EUROPA

Potes • Puerto de San Glorio • Portilla de la Reina •
Puerto de Pandetrave • Posada de Valdeón • (Caín) •
Puerto de Panderruedas • Desfiladero de los Beyos •
Cangas de Onís • (Covadonga) • Arenas de Cabrales •
(Sotres and Tresviso) • Panes • Desfiladero de La
Hermida • Potes • (Fuente Dé) • Potes

*198km/124mi; about 6-7 hours' driving without detours (add 14km/
9mi, 1h for Detour 1 to Caín; 36km/22.5mi, 1h30min for Detour 2 to
Covadonga; 52km/32.5mi, 2h for Detour 3 to Sotres and Tresviso, and
51km/32mi, 1h15min for Detour 4 to Fuente Dé).*

En route in the main tour: ☞ at Fuente Dé and Puerto de Pandetrave;
Picnics (see *P* symbol and page 10): 1, 3, 5; Walks: 1, 2, 3, 4, 5, 9
(Alternative); Short walks ☞ 1, 2, 3, 5, 6

*You can start this tour at any point, but unless you leave at the crack of
dawn, or spend a night en route, you will probably not have time to
take in all the detours. Wherever you are based in the Picos de Europa,
there will almost certainly be one detour that could be left for another
day (the glacial lakes in the Covadonga National Park from Cangas de
Onís, Sotres and Tresviso from Cabrales, or Fuente Dé from Potes, for
example). Beware of tour coaches occupying the whole road in the
narrow gorges and on the zigzag up to Covadonga. In addition, some
stretches of road are rather vertiginous, especially the section between
Potes and the Puerto de San Glorio, that between Sotres and Tielve,
and the route from Covadonga up to the glacial lakes. Between
November and May, some of the mountain passes, especially San
Glorio, may be snow-bound: check with the local tourist office or
police station beforehand if in any doubt. It is advisable to fill up with
fuel before starting out, as petrol stations are few and far between, and
the more remote ones offer only four-star and diesel.*

This car tour circumnavigates all three massifs of the
Picos de Europa: Cornión in the west, Urrieles in the
centre and Andara in the east. The scenery changes by
the minute: sheer limestone gorges alternate with gently-
rounded foothills, bleak upland heaths and verdant,
tree-lined valleys.

Head south out of **Potes★** (☗♠✕☕⊕) on the N621
towards León, taking the turn-off between Hostal Picos
de Europa and Mesón Los Camachos (Walk 1 also starts
and finishes at this junction, in the setting shown on
pages 48-49). The road snakes its way up in a long series
of hairpin bends, passing through the village of **Vega de
Liébana** (8km ♠✕⊕☞). The highest pass in the circuit
is the **Puerto de San Glorio★** (27km ☞; 1609m/5275ft):
the view from here looking east is absolutely superb first
thing in the morning, when the valley bottom is often
filled with a sea of low-lying cloud (see photograph
pages 72-73). Walk 5 starts from this col, on the track
leading north to the Collado de Llesba, from where you
would enjoy the view shown on page 12 (*P1*).

West of San Glorio, the road takes you through a broad valley of subalpine meadows, dotted with thousands of narcissi in spring and small herds of cattle in summer, before arriving at **Llánaves de la Reina** (32km ▲✕🚌; Short walk 🚌1). Continuing through a narrow gorge of dark conglomerate rocks, you arrive at **Portilla de la Reina** (37.5km ✕), a hamlet where human beings

Regional dancing is still popular with young people in Asturias, and the troupes travel all over the north of Spain to entertain at local fiestas, such as here in Potes, at the Fiesta de la Cruz.

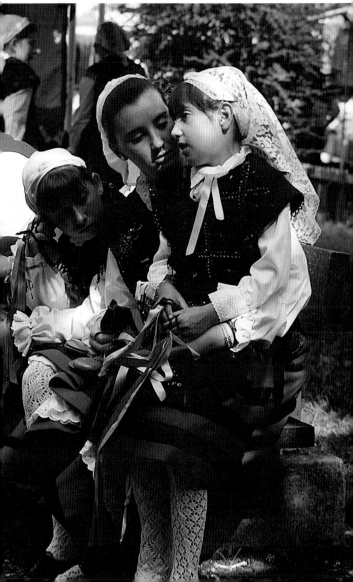

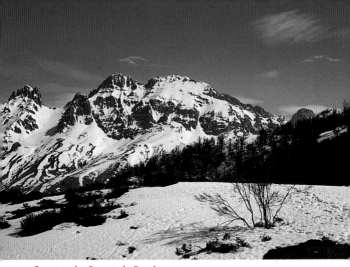

Snow at the Puerto de Pandetrave

are vastly outnumbered by goats. Fork right just past the village, signposted to Santa Marina de Valdeón.

You are now heading north on the LE245 along the Río Yuso valley (*P5*), winding gently up to the **Puerto de Pandetrave** (⛺🏚; 1562m/5125ft; photograph above). From here a spectacular view of the Valdeón valley, sandwiched between the western and central massifs of the Picos de Europa, opens before you. Continue down into the valley in the setting shown on page 29 until you are just above Santa Marina. Then take an inconspicuous left turn down a tiny lane (barely wide enough for a single car) into **Santa Marina de Valdeón** (53km ▲✕△). For 3.5km, from here to Posada de Valdeón, pray that you don't meet any oncoming traffic, as passing places are few and far between (watch out too for some rather large potholes)! **Posada de Valdeón** (56.5km ♦▲✕⊕; 939m/3080ft), the 'capital' of the valley, is a good place to break for a morning coffee, and to decide if you have time to make the detour down the Cares river valley to Caín (notes page 30) or take Short walk 🚗2 (page 14).

From Posada take the LE244 to the southwest, passing Soto de Valdeón (✕△) off to the right almost immediately. The road meanders up to the **Puerto de Panderruedas** (66km; 1450m/4760ft), from where you can take a stroll up through the beech forest to the north, to the Mirador de Piedrashitas (📷*P3*).

From the pass, continue until you come to the junction with the C637/N625 (70.5km), where you turn right, crossing the forest-clad **Puerto del Pontón** (1290m/4230ft) a few minutes later. From here the road winds

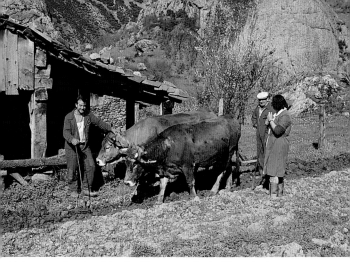

Using cows for ploughing is still common in the Picos de Europa.

down into the Río Sella valley in a series of hairpins, passing through the village of **Oseja de Sajambre** (82km ▲▲✕) in the setting shown on pages 22-23. Below Oseja the road enters the depths of the 10km-long **Desfiladero de los Beyos★**, carved out over millennia by the Río Sella through sheer walls of limestone.

You emerge from the gorge into the fertile lowlands which surround the town of **Cangas de Onís★** (116km ✝▲▲✕☐⊕☎), the first Christian capital of Spain at the start of the *Reconquista* (the seven centuries it took to oust the Moors from Spain). Look out for the inaccurately-named **Puente Romano★** (actually dating from medieval times) which spans the Sella at this point, and the Capilla de Santa Cruz, a 15th-century chapel which was built over a Celtic dolmen. Cangas de Onís, with its many cafés and restaurants, is an ideal place to stop for a snack — or even lunch — while you decide whether or not to take the detour up to the basilica and glacial lakes in the Covadonga National Park (notes page 31).

Head east out of Cangas de Onís on the C6312/AS114, passing the Covadonga turn-off after 4km and winding through fertile lowlands dotted with villages containing numerous Asturian granaries known as *hórreos* (Δ at Avín). On the approach to Carreña de Cabrales you pass through some splendid limestone country. If Short walk ▣3 (page 16) appeals to you, you pass the turn-off right to La Molina at **Canales** (138.5km). You may encounter roadworks on this stretch, currently held up by the discovery of a cave with magnificent Palaeolithic paintings when the road was being widened.

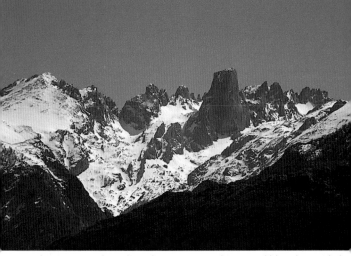

The Naranjo de Bulnes from Asiego. This incredible, sheer-sided limestone monolith was not conquered by man until 1904.

Just as you enter Carreña, turn left up to the village of **Asiego** (📷), which boasts an incredible view of the central massif of the Picos and the Naranjo de Bulnes★ (2519m/8265ft; see above). Then return through **Carreña de Cabrales** (144km ▲▲✕⊕), capital of the parish of Cabrales and renowned for its strong blue cheese of the same name. A few bends beyond Carreña, you come to the tiny roadside village of **Póo de Cabrales** (▲▲✕📷), from where the Naranjo de Bulnes is also visible.

From here it is only a stone's-throw to the bustling market town of **Arenas de Cabrales** (147.5km ▲▲✕ 🖳📷), from where you could branch off to Sotres and Tresviso, in the heart of the Picos (notes page 32).

Continuing eastwards along the C6312/AS114 from Arenas you almost immediately enter the sombre depths of the lower Cares Gorge; the river here is always the most dazzling shade of turquoise, due to the reflective properties of calcium salts suspended in the water. The road follows the river, passing through several small villages (most with roadside restaurants) before reaching **Panes** (170km ▲▲✕⊕), a rather gloomy town situated at the confluence of the rivers Cares and Deva.

From Panes you start on the home run: only a 28km-long, spectacular gorge — the **Desfiladero de La Hermida★** — lies between you and Potes. About 8km from Panes, pass the hydroelectric station at **Urdón**, which marks the start and finish of Walk 3, a steep ascent on an ancient mining track to Tresviso. At the midpoint of the gorge lies the village of **La Hermida** (182km ▲▲✕)

itself, so embedded in the depths of the defile that for five months of the year the sun never shines here. A turning on the right leads to Beges (see cover photograph), where Walk 2 begins and Alternative walk 9 starts and ends; 4.5km south, by a bus shelter on the right, a turn-off left leads to Short walk 🚗5 (page 18).

A little further on, you pass the pre-Romanesque church of **Santa María de Lebeña** (⛪) on your left (on the opposite bank of the river), complete with Mozarabic horseshoe arches and Celtic altar-stone (to visit it, turn sharp left just beyond the bridge, signposted 'Lebeña'). Just *before* the bridge, you pass a bar on the left called El Desfiladero, which is where Walk 2 ends.

Soon after the church, the walls of the gorge abruptly drop away and you enter the almost Mediterranean valley of Liébana, dotted with evergreen oaks and vineyards. Some 200m north of **Tama**, pass the turn-off left for Short walk 🚗6 (page 19). In **Ojedo** keep right, to cross the Río Bullón (access to Walk 4 is via the C627 signposted to Cervera de Pisuerga and Palencia). Once back in **Potes** (198km), carry on through the town to Fuente Dé, the headwaters of the Río Deva (Detour 4, page 34).

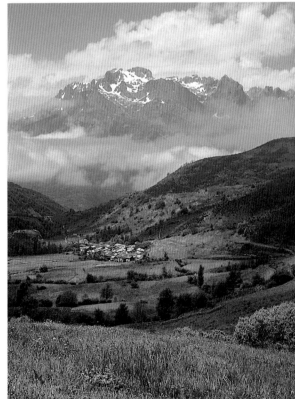

As you drop down into the Valdeón valley, you have this view of Santa Marina de Val-deón, backed by the western massif of the Picos de Europa.

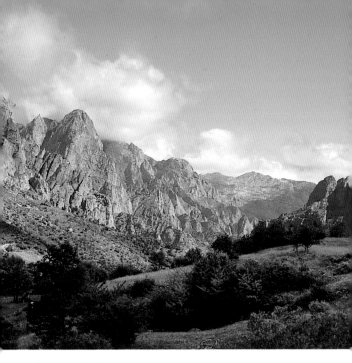

DETOUR 1: Caín

14km/9mi return trip; allow 1h
En route: Walk 7

Take the narrow road north out of **Posada de Valdeón** (to the left of the Hostal Begoña); it drops quite sharply down the valley in the setting shown above, to the village of **Cordiñanes** (🏨✕). After crossing the Río Cares you come to the **Mirador del Tombo** (📷; 866m/ 2840ft), marked by a statue of a chamois on a tall pillar. From here there are fantastic views of the Cares valley and the jagged peaks which encircle it.

Follow the road as it descends to the level of the river, past a recently reconstructed wolf-trap on the left (see above right). You soon enter the upper reaches of the **Garganta del Cares★**. At first the road is very narrow indeed and a little hair-raising. But after a few kilometres the valley widens out once more to accommodate the village of **Caín** (7km 🏨✕; 500m/1640ft). Walk 7, which begins at Puente Poncebos, turns back here, and Short walk 7 can begin or end here. The photograph on page 97 shows just one of the fabulous landscapes on this walk, which is perhaps *the* classic hike in the Cordillera Cantábrica. If you fancy stretching your legs in the more bucolic setting shown on page 93, leave your car here (in the summer you may be charged

Left: Looking north to the Cares Gorge, on the descent from Posada de Valdeón. Above: This wolf-trap has recently been reconstructed by the Covadonga National Park authority to demonstrate how the local people dealt with wolves until only a few decades ago. It consists of a deep circular pit with a funnel-shaped barricade leading into it from the hills above. The wolf was driven into the entrance of the funnel by men with dogs. A long drop into the pit at the far end prevented the wolf's escape and, thus confined, it was easily killed.

a small fee to park in one of the nearby fields) and follow the path along the left-hand side of the river to reach the start of the Cares Gorge proper, known locally as the Garganta Divina (the Divine Gorge).

To continue the car tour, return to Posada the same way.

Detour 2: Covadonga

36km/22.5mi return trip; allow 1h30min
En route: Walks 10 and 11; Picnic 2

Follow the C6312/AS114 east out of **Cangas de Onís** for about 4km, then turn right at a large junction signposted 'Covadonga' (there is a small zoo — Faunastur — on the corner here, with animals typical of the Cordillera Cantábrica, including brown bears, wolves and vultures). This road takes you up to the 19th-century basilica of **Covadonga★** (6km ♣▲✕; see overleaf), built on the site where the Visigothic prince Pelayo (later canonised) repulsed the Moorish armies in a decisive battle in 718; it was the turning point in the Arab occupation of Spain.

To continue up to the glacial lakes *(not a road recommended for nervous drivers, especially in poor weather)*, turn sharp left just *before* the monastery, following 'Lago de la Ercina, Lago Enol'. Wind your way up through meadows and alpine rock gardens, passing

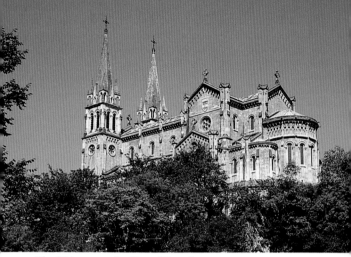

The 19th-century basilica of Covadonga

the **Mirador de la Reina** (📷), from where you can see the vulture feeding station. The first lake you come to is **Lago Enol** (photograph pages 112-113), but carry on over the crest of the hill for the second lake — **Lago de la Ercina★** (18km ✗📷; 1100m/3610ft). As you can see in the photograph on pages 122-123, this lake is set against one of the most scenic backdrops in the Picos, dominated by the peak of Peña Santa de Castilla (2596m/8515ft). Walks 10 and 11 start and finish here. A stroll around the edge of the lake (about half an hour) is well worthwhile (**P2**).

To continue the car tour, return to the junction with the C6312/AS114 and turn right.

Detour 3: Sotres and Tresviso

52km/32.5mi return trip; allow 2h
En route: Walks 3, 7, 8, 9; Short walk 🚶4

Take the road due south from the centre of **Arenas de Cabrales**; it crosses the Río Cares almost immediately, before zigzagging up the hill and into the middle section of the Cares Gorge. After 6km you come to the junction at **Puente Poncebos** (⛰✗), where Walks 7 and 8 start and finish. If you are feeling particularly energetic, follow the start of Walk 7 (pages 92-93), but leave it just after five minutes and take the path signposted 'Bar/ Comidas' up to the tiny perched hamlet of Camarmeña (📷). From here you will have another fine view towards the Naranjo de Bulnes shown on page 28 — this time from a different angle.

Back at Puente Poncebos, turn sharp left over the

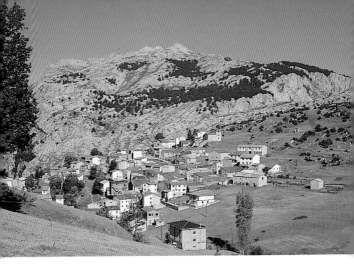

Sotres

river (this time the Duje), and follow the narrow, some-what hair-raising road that clings to the limestone cliffs high above the river. After passing the hamlet of Tielve (▲✕) on your left and a wide track on the right (19km; parking for Short walk ⊟4), you come into **Sotres** (20km ▲✕; 1045m/3430ft), the mountain village shown above. Continue east uphill. After 3km you come to a junction at **Jito de Escarandi**, where Walk 9 begins and ends. The road ends in the remote hamlet of **Tresviso** (✕), famous for its strong *picón* cheese (see page 10). Walk 3, which has climbed the zigzags shown on page 63, turns round here; the short version can begin or end here.

Return to Arenas de Cabrales the same way to con-tinue the car tour.

Looking north towards Sotres from the Vegas de Sotres, on a brilliant day in December

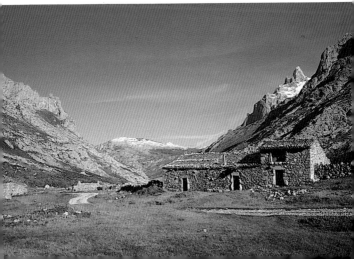

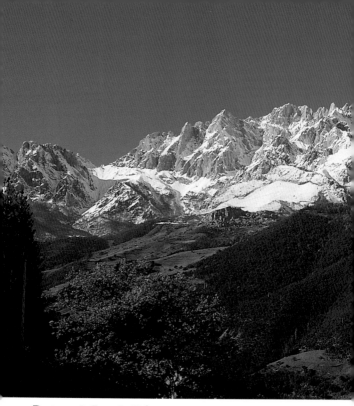

DETOUR 4: Fuente Dé

51km/32mi return trip; allow 1h15min
En route: 🄿 at Fuente Dé; Walks 5, 6; Picnic 4

Drive straight through **Potes** on the road signposted to Fuente Dé, leaving the huge square edifice of the Torre del Infantado★, which dates from the 15th century but nowadays houses the offices of the town hall, on your right. Within a kilometre turn left, following signposting to Santo Toribio (∆ at **Mieses**). Dating from the 8th century and once a Cluniac monastery, **Santo Toribio de Liébana★** (🛉) was one of the most influential bastions of the Church in medieval Spain, but houses only a handful of Franciscan monks today. The complex also contains a lovely 11-13th century church, the side chapel of which houses a large crucifix (said to contain, beneath its bejewelled exterior, an entire arm of the cross on which Christ was crucified). From the **Ermita de San Miguel** (📷), at the end of the road you have the wonderful view of the eastern massif of the Picos shown above.

Return to the main road and carry on up the valley, following the course of the Río Deva almost exactly and

The massif of Andara, as seen from the viewpoint at the Ermita de San Miguel. The combination of snow-covered limestone peaks, haymeadows and Mediterranean forests is quite unique.

passing through numerous tiny villages, most of which offer restaurants and accommodation (Δ at **Turieno** and **San Pelayo**). The vernacular architecture of these villages is delightful, with their pantiled roofs and heraldic coats of arms carved from huge blocks of stone (see photograph page 2). And always, towering above you to the right, are the jagged limestone peaks of Andara.

The village of **Los Llanos** (✕) lies at about the halfway point on this road: Alternative walk 6 finishes here. A few kilometres further on, you pass through **Cosgaya** (▲▲ ✕), where Walk 5 ends and Alternative walk 5 starts and finishes.

Just after **Espinama** (▲▲✕), where Short walk 6 ends, the road terminates in the superb natural amphitheatre of **Fuente Dé★** (23km ▲▲✕Δ🏠🅿), one of the most popular tourist destinations in the Picos de Europa. From here, the longest single-span cable car in Europe takes you from 1100m to over 1800m (3600-5900ft) in just three minutes: the views from the top are definitely not to be missed (🚠*P*4). Walk 6 begins at the upper cable car station, in the setting shown on page 86.

Return to Potes the same way.

❀ Walking

While writing this book I have tried to include routes which take in *all* the main ecosystems in the Picos de Europa, not just the high mountains, on which most attention has been focused to date. You will find walks which take you through the superb haymeadows of the area — considered to be some of the richest Atlantic grasslands in the world — as well as through extensive forests of beech, Pyrenean oak and the evergreen Mediterranean woodlands of Liébana. The celebrated walk through the sombre depths of the Garganta del Cares is included here, as are a number of routes which explore the vast wilderness of limestone which forms the heartland of the Picos.

In addition to the classic routes, I have also included some walks which lie well off the beaten track, where your only human encounters will be with the local people: shepherds and cowherds, or folk harvesting the natural bounty of these mountains — chestnuts and walnuts, chanterelles, trout and even snails! Above all, I hope that this book will encourage you to explore further afield in the Picos de Europa, where every corner turned holds another surprise, another memorable encounter with a world apart.

A few words of caution. **Do not underestimate the Picos de Europa. The higher reaches of these mountains are true wilderness, and must be treated with respect:** *never* **try to link one walk with another on uncharted terrain.**

Most of the walks in this book are within the capability of any reasonably fit person, although in some cases there is a risk of vertigo. Of course, you must take the season and weather conditions into account before embarking on a walk: for example, some of the routes into the higher mountains may be snowbound between November and May, while low-lying cloud may make route-finding difficult, as well as obscuring all the best views. **Remember too that storm damage can create hazardous conditions for walking** *at any time.*

If you are not an experienced walker, you may like to cut your teeth on some of the very short walks described in the Picnicking and Short walks sections on pages 10-

21, before progressing onto the shorter alternatives of the main walks.

Guides, waymarking, maps

There are several companies which offer **guided walks** in the Picos de Europa, especially in Cangas de Onís, Cabrales and Potes: ask at the local tourist office for details. In Liébana, you could contact the Casa Gustavo Guesthouse in Aliezo, near Potes, for information (Tel. 942-73 20 10): the owners speak English and have an extensive knowledge of the southern reaches of the Picos. In Cabrales, a company called Spantrek offers daily guided walks (Tel. 98-584 55 41). You might also like to get in touch with me (Tel. 942-73 62 57), especially if you have an interest in wildlife.

Waymarking is almost non-existent in the Picos de Europa, although there are moves afoot to signpost some of the more popular walks, especially in Asturias. Most of the high-mountain routes have some sort of informal waymarking, be it paint-splodges on the rocks or a series of cairns, but I would advise you never to *depend* on such systems, and **always carry a map and compass.**

The **maps** in this book have been adapted from the 1:50,000 Spanish military maps of the Picos de Europa. These provide the best available coverage of the whole range. They were published in the early 1980s, and so are unfortunately quite out of date (we have updated the sections reproduced in this book). If you wish to supplement our maps, I recommend the 1:25,000 maps produced by Miguel Angel Adrados: the western massif is covered by *El Cornión — Macizo Occidental de los Picos de Europa*, the central and eastern massifs by the map entitled *Los Urrieles y Andara*. Both are widely available in bookshops throughout the Picos.

Where to stay

For walks in the southern reaches of the Picos de Europa, the best base is probably **Potes** (although it can get very busy in high summer), as there is a wide choice of accommodation and buses serving three out of the four valleys which diverge from the town. You could also try one of the villages on the Potes-Fuente Dé road, which may be more peaceful.

On the north side of the Picos, **Cangas de Onís** is the best choice if you want to explore the Covadonga

National Park, while **Arenas** is a better base for the region of Cabrales, including the Cares Gorge. Again, both have a wide selection of accommodation.

If you are **camping**, there are sites near Arenas de Cabrales, Avín and Cangas de Onís in the north, and in Turieno, San Pelayo, Mieses and Fuente Dé in the Río Deva valley west of Potes in Liébana, as well as a more tranquil one near Vega de Liébana, about 8km up the

Drummer and gaitero at Potes. The gaita, or bagpipe, is still widely appreciated in regional folk music in northern Spain — yet another indication of the Celtic roots of these people.

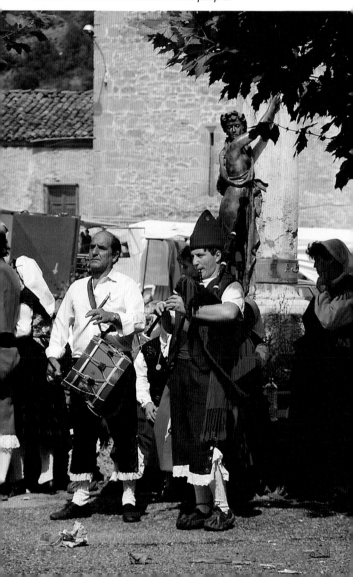

road which connects Potes with the Puerto de San Glorio. Valdeón also has two campsites: one at Soto de Valdeón, and one near Santa Marina, but walking from these bases is extremely difficult, as the sides of the valley are very steep and the bus service is all but non-existent.

Weather hints

Situated only about 25km/15mi from the sea, the northern reaches of the Picos de Europa are profoundly affected by depressions sweeping in across the Atlantic Ocean, such that the climate is warm but wet, and the tops of the mountains are often shrouded in mist. In contrast, the southern valleys lie in the lee of the highest peaks in northern Spain outside the Pyrenees, and in consequence, precipitation is lower and the climate is markedly Mediterranean in character.

During the winter months, snow falls heavily down to about 1000m/3280ft, sometimes persisting until June on the highest north-facing slopes. As a result, some of the walks described in this book may be impassable in winter — and even the car tour, given that it crosses four mountain passes, may not be feasible.

Some mornings in the summer you may wake to find the cloud level barely above your head: this is the result of a temperature inversion, and by midday the cloud has usually dissipated completely. In contrast, I have a marked mistrust of summer mornings that dawn unusually clear, as they often lead to an afternoon thunderstorm: *do* make an early start under such conditions.

Be warned that mists can build up in the high mountains at any time of day or in any season, so make sure that you always take adequate clothing, extra rations and a compass. It is also important to remember that at altitude the rays of the sun are much stronger, so even if a cool breeze is blowing, make sure you wear your sunhat and apply a high-factor sun-tan lotion.

Clothing and equipment

If you are already in the Picos de Europa when you discover this book, and haven't brought walking boots, or a rucksack, with you, don't despair: you can still do some of the easier walks, providing that you have strong footwear, or you could visit one of the shops in Cangas de Onís or Potes where specialist walking equipment is sold. However, do not attempt any of the more difficult

walks without being properly equipped. For each walk in this book, the *minimum equipment necessary* is listed.

Where walking boots are required, there is *no substitute:* you will need to rely on the grip and ankle support that they provide, as well as their waterproof qualities. On all other walks, you will need stout, lace-up shoes with thick rubber or 'Vibram'-type soles, to provide a good grip: this is especially important on the walks which follow ancient trails, where the worn rocks underfoot can be extremely slippery in both dry and wet conditions.

You may find the following checklist useful:

walking boots (which *must* be broken-in and comfortable)
waterproof raingear (all year round, as unexpected showers are a
 common occurrence in the Picos)
long-sleeved shirt (for sun protection, especially on the high-
 altitude walks)
first aid kit, including bandages, plasters and antiseptic cream
plastic plates, cups, etc...
anorak (zip opening)
spare bootlaces
sunhat, sunglasses and protective sun-tan lotion
whistle, matches and torch
compass and 1:25,000 map (see page 37, 'Guides … maps')
plastic bottle with water purifying tablets
long trousers, tight at the ankles
knife and tin-opener
2 lightweight cardigans or a 'fleece'
extra pair of socks
gloves
small rucksack
insect repellent
Dog Dazer (see under 'Dogs'), or a stout stick

Please bear in mind that I've not done *every* walk in this book under *all* possible weather conditions: use your judgement to modify the above list accordingly. In hot weather, *always* wear a sunhat and make sure that you apply your sun-tan lotion sensibly. Don't forget your sunglasses if you are venturing out while there is still snow about.

Dogs — and other nuisances

In general the **dogs** in the villages around the Picos de Europa are small and noisy, but their bark is definitely worse than their bite. In the high mountains in the summer, however, you will almost certainly encounter the huge *mastín* sheepdogs (rather like short-haired Pyrenean mountain dogs), complete with nail-studded collars as a defence against wolves. These creatures

may seem rather intimidating, but as long as you steer clear of their ovine charges there should be no problem. If you have any doubts, carry a stout stick, or a Dog Dazer (the ultrasonic device which frightens dogs off without harming them, available from Dazer UK, 51 Alfriston Road, London SW11 6NR).

Whilst passing through herds of **cattle** in the high summer pastures, take care not to come between young calves and their mothers, as an upset cow is a formidable beast indeed, especially given the size of the horns on the native breeds! The bulls often graze freely alongside the cows in the high mountains, but I have never yet heard of one attacking a person, so give them a sensible berth, but don't panic! In the same way, treat all stallions with caution, and *never* attempt to approach mares and their foals.

Otherwise, you are unlikely to encounter any problematic animals during your excursions in the Picos:

Walk 3: Looking ahead from the Balcón de Pilatos, from where the walled edges of the third set of zigzags can be seen winding up the cliff in the background

Although it looks more like a bumblebee, the narrow-bordered bee-hawk (Hemaris tityus) is in fact a day-flying moth. Look out for it sucking nectar from haymeadow flowers in the southern parts of the Picos.

bears, wolves and wild boar are infinitely more frightened of you than vice versa, and will be long gone without you even realising they were there. The same applies to **Seoane's viper**, the species of adder which occurs only in the north of Spain; however, as a precaution, do not walk through bracken or heather wearing sandals, or with bare legs.

In the summer, you may find **mosquitoes and clegs** (the latter sometimes called horseflies) a nuisance in the valleys, but this problem can be resolved by the judicious application of insect repellent. In addition, in particularly hot, dry years, the numbers of **wasps** can reach almost plague proportions, so if you know that you are allergic to their venom, *carry an antidote with you at all times.*

From September to February, **boar hunting** takes place all around the Picos de Europa at weekends and on feast days, using hounds to drive the quarry towards the waiting marksmen. However, this activity seems to be more an excuse to spend a day in the country with friends, rather than producing any realistic chance of shooting a wild boar. Rarely do you hear a single shot, and you will only realise that a hunt is in progress when you come across a rather bored, khaki-clad gentleman lounging on a prominent rock overlooking the valley, or from the distant baying of excited dogs.

General advice to walkers

The following points cannot be stressed too often:
- **At any time a walk may become unsafe due to storm damage or bulldozing**. If the route is different from the description in this book, and your way ahead is not secure, do not attempt to continue.
- **Walks above 1000m/3300ft may be hazardous in the winter**, when the route may be obscured by snow; *all* routes can be dangerous in poor visibility, when there is a very real chance of losing your way.
- **Warm clothing** is always needed in the high mountains, even in the summer.

■ **Never walk alone** — four is the best walking group. If someone is injured, two can go for help and there is no need for anyone to be left alone.

■ **Do not overestimate your capability**: your speed will be determined by the slowest member of the group.

■ **Bus connections** at the end of a linear walk may be vital. Always check departure times *before* setting out.

■ **Adequate footwear is vital.**

■ **Mists** can suddenly appear at higher elevations, when a compass might make the difference between life and death.

■ **A first-aid kit, compass, whistle and torch** weigh little, but might save your life.

■ **Extra rations** must be taken on longer walks.

■ **Sufficient water** must be carried at all times, especially in summer, as there is little surface expression of water on the limestone.

■ **Always follow the country code** on page 46, and read carefully the 'Important note' on page 2 and the guidelines on grade and equipment for each walk you plan to take.

Language hints

In the countryside it is always useful to have a few words of Spanish ready in order to greet people and, if necessary, ask directions. Here's one way to ask directions and understand the answers you get. First memorise the few 'key' and 'secondary' questions below; then **always follow up your first question with a second one which requires a 'yes' or 'no' answer, for confirmation.** An inexpensive Spanish phrasebook will help you with the pronunciation and construction of other 'key questions'.

Asking the way

The key questions:

English	Spanish	Approximate pronunciation
Hello	Hola	**Oh**-lah
Good day	Buenos días	**Buey**-nohs **dee**-ahs
Sir, Madam, Miss	Señor, Señora, Señorita	Sehn-**yohr**, sehn-**yoh**-rah, sehn-yoh-**ree**-tah
I am lost.	Me he perdido.	May ay per-**dee**-doh.
Please ...	Por favor ...	Pohr fah-**vohr** ...
Where is	¿Dónde está	**Dohn**-day es-**tah**
the road to ...?	la carretera a ...?	lah kah-rah-**tay**-rah ah ...?
the path to ...?	el sendero a ...?	ell sen-**day**-roh ah ...?
the bus stop?	la parada de autobús?	lah pah-**rah**-dah day ow-toh-**boos**?
Many thanks.	Muchas gracias.	**Moo**-chas **grah**-thee-ahs.

Secondary questions, leading to a 'yes/no' answer:

Is it this way?	¿Es por aquí?	**Ehs** pohr ah-**key**?
Is it over there?	¿Está allá?	Es-**tah** al-**yah**?
Is it straight ahead?	¿Está todo recto?	Es-**tah** toh-doh **rayk**-toh?
Is it behind?	¿Está detrás?	Es-**tah** day-**trahs**?
Is it to the left?	¿Está a la izquierda?	Es-**tah** ah lah ith-key-**air**-dah?
Is it to the right?	¿Está a la derecha?	Es-**tah** ah lah day-**ray**-cha?
Is it above?	¿Está arriba?	Es-**tah** ah-**ree**-bah?
Is it below?	¿Está abajo?	Es-**tah** ah-**bah**-hoh?

Asking a taxi driver to take you somewhere and return for you:

Please ...	Por favor ...	Pohr fah-**vohr** ...
Take us to ...	Llévenos a ...	L-**yay**-vah-nohs ah ...
Come and	Venga a	**Bayn**-gah ah
pick us up	buscarnos	boos-**car**-nohs
at ... (place)	en ...	en ...
at ... (time)	a ...*	ah ...

*It is sufficient to point at your watch, to indicate the time you wish to be collected, or to write it down.

Glossary

Some of the Spanish terms common to the Picos de Europa may be unfamiliar even to those of you who speak the language. Below is some useful vocabulary, with approximate pronunciation.

arroyo — stream (ah-**rroy**-oh)
calle — street (**kahl**-yay)
collado — mountain pass (kohl-**yah**-doh)
desfiladero — gorge (literally 'defile'; days-fee-lah-**day**-roh)
ermita — chapel (air-**mee**-tah)
fuente — spring (water; foo-**ayn**-tay)
garganta — gorge (literally 'throat'; gahr-**gahn**-tah)
hito, jito — boundary mark, cairn (**ee**-toh)
invernal — a barn where livestock spends the winter (een-vair-**nahl**)
lago — lake (**lah**-goh)
majada — a barn where livestock spends the summer (mah-**hah**-dah)
mirador — viewpoint (mee-rah-**door**)
peña — peak (**payn**-yah)
pico — peak (**pee**-koh)
pozo — well (**poh**-thoh)
prado — meadow (**prah**-doh)
puente — bridge (poo-**ayn**-tay)
puerto — mountain pass (poo-**air**-toh)
refugio — mountain hut, refuge (ray-**foo**-hee-oh)
río — river (**ree**-oh)
riega — stream (ree-**ay**-gah)
ruta — route (**roo**-tah)
sierra — mountain ridge (see-**ay**-rah)
vado, vao — ford (**bah**-doh)
valle — valley (**bahl**-yay)
vega — alpine grassland, often used as summer grazing (**bay**-gah)

Organisation of the walks

The 11 main walks in this book are divided between the northern and southern reaches of the Picos de Europa, using Cangas de Onís, Arenas de Cabrales and Potes as the principal points of departure.

When planning a walk, you might start by looking at the large fold-out map of the Picos de Europa inside the back cover, which shows you at a glance the general terrain, the road network and the location of the walks that are nearest to you. Then turn to the route notes and the accompanying large-scale maps.

Each walk is described in the direction which I feel is the most attractive and poses the fewest transport problems (generally any ascents come early on in the route). Please feel free to try them in reverse — or to shorten 'out and back' routes, if you have friends who are willing to play taxi.

To give you an idea of the settings of the various walks, there is at least one photograph for each.

Each itinerary begins with planning information: distance, grade, necessary equipment and details of access. Pay particular attention when I refer to the ascent: although the average walker may be able to tackle 600m/2000ft without too much difficulty, anything more requires a higher level of fitness. Times are given for various landmarks in each walk, but please bear in mind that everyone walks at a different pace, and that your speed will also vary according to the load that you are carrying, the time of day, weather conditions, etc. As a rule of thumb, calculate 13 minutes for every kilometre on the flat, plus an extra 13 minutes for every 100 metres of ascent. Bear in mind as well that some of the more difficult *descents* may also slow you up. No time for stops is included, so make sure that you allow plenty of extra time for lunch, birdwatching or botanising, and photography.

The following symbols are used on the walking maps:

▬▬▬	main road	▲ ▲ ▣ church. chapel. cemetery
———	forestry or other track	⊥ ▰ monument. school
— ––	cart track. footpath	◦ ♀ well. spring
→	main walk and direction	✕ ▣ quarry. transformer
⇢	alternative walk	╟600╣ height in metres
〰	habitations, *majadas* or *invernales*	🚌 🚗 bus stop. car parking
		👓 best views

A country code for walkers and motorists

The experienced walker is accustomed to following a 'country code' on his walks, but the tourist may not have the necessary knowledge to avoid causing damage to property or livestock, and may even endanger his own life. A code of practice for the countryside is especially important in the Picos de Europa, where the rugged terrain could cause dangerous mistakes.

- **Only light fires** at picnic areas equipped with fireplaces or barbecue facilities. Stub out cigarettes with care.
- **Do not frighten animals.** The livestock, be it cows, sheep, goats or horses, that you meet on your walks is not tame. By making loud noises, or trying to touch or photograph these animals, you may startle them and cause them to run and hurt themselves. **For this reason, always keep your dogs on a lead.**
- **Walk quietly** through all hamlets and villages, taking care not to provoke the dogs, and treating the inhabitants with courtesy.
- **Leave all gates just as you find them**, whether in the villages or on the mountainside. Although you may not see any livestock, the gates serve a purpose: they are used to keep animals in (or out of) a specific area. Here again, livestock could be damaged by careless behaviour.
- **Do not pick wildflowers or other plants**, whether wild or cultivated; leave them for others to enjoy.
- **Stay on the path wherever possible**: taking short cuts causes serious erosion, especially on steep slopes, as well as damaging the surrounding vegetation.
- **Never walk across private property**, which in the Picos de Europa includes all haymeadows: if you trample them you are damaging a farmer's crop, and thus his livelihood.
- **Take *all* your litter away with you.**
- **DO NOT TAKE RISKS!** This is the most important point of all. Do *not* attempt walks beyond your ability, and do not wander off the paths described in this book if there is any sign of mist, or if it is late in the day. **Do not walk alone**, and *always* tell a responsible person where you are going and at what time you plan to return.

The sun-drenched southern valleys

The giant peacock moth (Saturnia pyri) *is one of Europe's largest insects. It can often be seen during the day or at dusk in the southern Picos. You might mistake it for a bat or a small bird, as its wingspan is over 12cm (about 5 inches)!*

1 POTES • FRAMA • LUBAYO • COLLADO DE PORCIEDA • TUDES • PORCIEDA • INVERNAL DE TOLIBES • POTES

Map page 51; additional photographs pages 25, 38
Distance: 13km/8mi; 4h

Grade: Moderate, with a short, stiff climb of over 500m/1640ft in the space of just 3km, followed by a gentle descent of the same; mostly on tracks and feasible all year round.

Equipment: stout shoes (preferably walking boots), sunhat, cardigan, raingear, picnic, water

How to get there and return: If you are not already in Potes, 🚌 PALOMERA (Tel. 942-88 11 06) runs from Santander to Potes and EMPRESA FERNANDEZ (Tel. 987-22 62 00) connects Santander with León via Potes. Or 🚗: park in Potes, near the junction with the N621, signposted 'Riaño, León'.

This walk is definitely best undertaken in the morning, firstly in order to make the most of the splendid views of the Picos de Europa from the Collado de Porcieda, and secondly because the steep ascent is a killer on a hot afternoon! The route takes you through three of the most remote villages in Liébana, with charming vernacular architecture, and gives you a taste of the typically Mediterranean vegetation of this south-eastern corner of the Picos. In particular, the descent through the cork oak forests of Tolibes is a unique

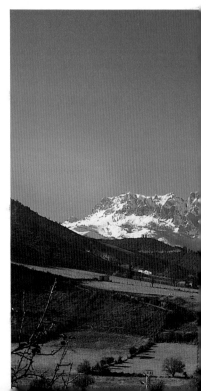

The eastern massif — Andara — of the Picos de Europa, with Potes, the market town of Liébana, in the foreground. The highest peak visible is Sagrado Corazón (literally 'sacred heart'), to which a pilgrimage on foot from Potes takes place every five years (the next one is in the year 2000).

experience in the Cordillera Cantábrica, as these trees usually are confined to more southerly regions.

Start the walk close to the eastern end of Potes, where the N621 turns off towards the Puerto de San Glorio and León. Walk about 30m/yds up this road, past the Hostal Picos de Europa, then turn left immediately along a narrow lane marked 'Calle Camino Viejo', asphalted at this point. You are walking parallel with the Potes-Ojedo road, visible down on the left, through an area of fenced pastures and new, chalet-style houses. Ignore all the side turnings leading to the various dwellings and follow the lane until the tarmac ends at a T-junction (**15min**). Here turn right, and enter the Río Bullón valley, now on a gravel track.

Ahead you can see the village of Frama, nestling in the valley bottom: stay on this undulating main track until you reach the first of the houses. The hedges on either side are dominated by evergreen Mediterranean shrubs and trees, including holm oak, strawberry tree, *Phillyrea latifolia*, wild privet and Mediterranean buckthorn, interspersed with deciduous species such as field maple, spindle, wild cherry and turpentine tree — the latter known as *cornicabra* in Spanish, on account of the

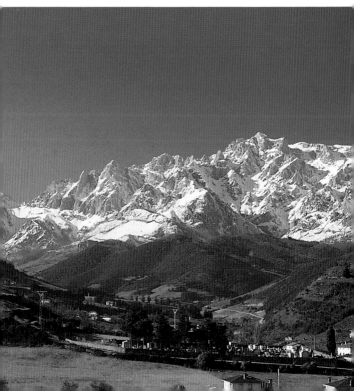

galls shaped like goats' horns with which it is often infested. Up to the right, the slopes are clothed in a mosaic of haymeadows, patches of Monterey pine and vineyards.

Pass a water trough and spring by the side of the track, then a track joins yours from the right (**25min**). A couple of minutes later, approaching the outskirts of Frama, come to a house, also on the right, where you find concrete underfoot once more: ignore a right turn leading up to a double galvanised iron gate here. At about **30min** pass a small trout farm on the Río Bullón down on the left, by an old mill-house. At this point the concrete surface gives way to tarmac, and you emerge into a large square, with several exits. Of the two routes leading out of the far side of the square, take the right-hand one, a stony track which climbs steeply and veers round to the right almost immediately. This is the start of the ascent to Lubayo and the Collado de Porcieda.

The track ascends more or less parallel with the Riega Quintana, down on the right, and describes several curves before the gradient becomes less severe. Heath-like vegetation, dominated by Spanish broom, ling, Cornish heath and bell heather, clothes the rocky outcrop on the left, while the banks of the stream support willows and tall poplars. A few minutes up, a grassy track joins from the left, and at **55min** your track meets a larger one, much used by vehicles, also coming in from the left, where you turn right.

This rough, stony track is the main access road to the remote village of Lubayo. Steep ascents alternate with more level sections that give you time to catch your breath and admire the view of the eastern massif of the Picos de Europa to the north and the long ridge of Peña Sagra (shown in the photograph on pages 72-73) to the east. You arrive in Lubayo at **1h30min**, the approach heralded by a section of concrete underfoot, walled meadows on either side and an avenue of walnuts and lopped and topped ashes (photograph page 55). Many of the houses in this village are built from blocks of stone without any form of mortar in between, and most have wooden balconies, often adorned with grapevines.

Head straight up through the village, ignoring any side turnings, until you arrive at a fork with a stone water trough in the centre; keep left here, on the concrete track which climbs very steeply; a walled meadow is on the left and a shaly bank topped with

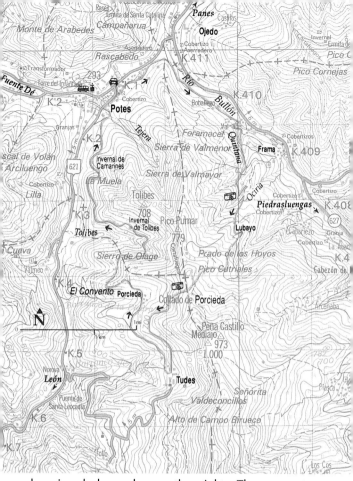

overhanging holm oaks on the right. The concrete disappears almost immediately, giving way to a rough stony surface once more. This track winds up through more open terrain, dominated by brooms and green-weeds, tree heath, gorse and bracken, the evergreen oaks having disappeared completely. Many birds frequent this habitat, including stonechats, whinchats and red-backed shrikes, the latter known as 'butcher birds' on account of their habit of impaling their prey — grasshoppers, small lizards, etc — on thorns (or barbed-wire fences!), in a sort of avian 'larder', to eat them at their leisure.

Stay on the main track until, at **1h45min**, you arrive at a three-way junction, marked by a grove of holm oaks and a few stunted bushes of prickly juniper: take the right-hand fork here (the most obvious), which again climbs steeply. It takes you through very dry, rocky

terrain, decorated with such aromatic Mediterranean shrubs as round-headed thyme, everlasting flowers, French lavender and sage-leaved cistus, contrasting with the velvet-green appearance of the meadows around the Riega de Ociria down on your left. Goldfinches, rock buntings and yellowhammers abound here, especially in winter.

By **2h10min** most of the hard work is done for the day, and the track levels out somewhat as it crosses a section of meadow — the wheel-ruts are obvious — then climbs towards a plantation of Monterey pines on the far side. Just before these mature pines, you hit a T-junction and turn left: the wide track heading down to the right along the edge of the pines probably doubles as a fire break. You are now climbing gently between the bulk of the plantation on your right, and a line of young cypresses on your left.

At the junction reached about ten minutes later, take the right-hand, uphill fork, which leads you to the Collado de Porcieda (**2h25min**), scarred by a wide fire-break running along the crest of the ridge. There is a stunning view of the Picos de Europa from here, with Andara in the foreground, and the shadowy silhouettes of the higher peaks of Urrieles beyond.

Cross straight over the firebreak and follow the continuation of your track down the other side of the col, through young Pyrenean oak woodland interspersed with flowering greenweed, white-flowered *Cistus psilosepalus* (see opposite) and scrubby holm oaks. Directly ahead of you is the bulk of the Sierra de la Viorna, topped by a large stone cross: it is from here, according to legend, that an arrow was shot, and where it landed the Monastery of Santo Toribio was built. Immediately below you, down on the right, is the hamlet of Porcieda, which you will visit later.

First, however, follow the stony track as it descends quite steeply towards the village of Tudes. Five minutes down from the col, just before the track levels out, ignore a right turn which leads into the meadows of Porcieda. Contour to the left around the hillside and then drop down more gently, first through holm oak scrub and then through dry, acid meadows. As you approach Tudes, take note of a modern white house down on your right, a couple of hundred metres before you reach the village; this house lies on the track to Porcieda — the next section of your route.

Cistus psilosepalus

A very large holm oak tree on the right greets you just before you reach the first houses of Tudes. At **2h40min**, just after this tree, the main track continues up to the left above the village, but you turn sharp right, directly towards a large stone house with a semi-cylindrical bread oven, roofed with pantiles, protruding from the wall which faces you.

Looking at this oven, if you turn back to the left, on the concrete road, you can wander around Tudes, which possesses some wonderful vernacular architecture, but unfortunately no bar! Your onward route turns *right* here, along a narrower track lined with slimline poplars and ash trees; it runs parallel with the one which led you into the village.

About five minutes after leaving Tudes, you pass above the modern white house which you could see during the descent from the col: reassurance that you are on the correct route. Keep straight on here, descending gently through extensive dry meadows and holm oak forest, until you come to a junction at about **2h50min**. Take the right-hand fork, and keep dropping until you reach another junction, where you again take the right-hand option. Just before you enter the village of Porcieda, fork left, so as to leave the chapel on your right. This shrine is the only building in a reasonable state of repair in the whole hamlet, as nobody but a multitude of birds, including red-legged partridges, green woodpeckers and bullfinches, lives here today; most of the houses are on the verge of ruin.

The narrow track leads you into the 'centre' of the hamlet at **3h**, towards a whitewashed stone house with a small wooden balcony: through the broken-down door of the larger house to the right (which has a longer balcony, occupied by beehives), you can see the

Harvested cork oaks. These trees are more usually associated with southern Spain and Africa.

remains of an old wine-press. Your route lies to the left of the whitewashed house, on a track which bends round to the left, past a wooden door in a tall stone wall on the right-hand side. It then veers immediately to the right and becomes a narrow, somewhat over-grown path, running between meadows lined with tumbledown stone walls: an empty concrete water tank on the left indicates that you are on the correct route.

Within a few minutes, at the end of this overgrown path, you reach the holm oak woodland again, here veering to the left up the hill on a more obvious rocky trail. About five minutes later, when you arrive at a fork in the trail, take the narrow path which branches off to the left. This path contours around the flanks of a west-wards-pointing spur known as El Convento: it once housed an important religious building, now little more than a pile of stones which has been reclaimed by the forest.

On rounding the tip of the spur, you find yourself on the edge of the largest cork oak forest in the Cordillera Cantábrica: this tree is more usually associated with southwest Spain and northwest Africa, and its presence here is a true botanical anomaly. The cork is harvested every decade or so by traders from Extremadura, who remove their booty on mule-back. A delightful path runs through this luxuriant evergreen woodland, before widening substantially on veering around to the right and across the northern face of the spur. Follow this undulating trail through the cork oaks as it contours around the two tributary valleys of the Riega de Tolibes, ignoring all side turnings. You drop down to the Invernal de Tolibes, in a large meadow on the left, at

The ash tree on the left has just been lopped and topped; the one on the right is about to undergo its biennial pruning.

3h25min. Plenty of strawberry trees accompany the cork oaks, providing a year-round feast for a wealth of small birds: short-toed eagles are also known to nest in these woods.

At the Invernal de Tolibes, the trail becomes a track again, which you follow all the way down to Potes. The cork oaks thin out on the sunnier slopes, with the rock outcrops on the right supporting natural *bonsais* of many species, primarily prickly juniper and holm and cork oaks. The remains of terraces on these west-facing slopes indicate that they were probably used for growing grapes in times past, as is still the case on the opposite side of the valley. Unfortunately, as you approach Potes, fly-tipping becomes more common, with abandoned objects including even fridge-freezers and motorbikes! At **3h45min**, pass the Invernal de Camarines (little more than a cow byre) on the right: at this point, the forest and scrub surrender their domain to meadows and pastures, interspersed with small blocks of Monterey pines.

Eventually, the stony surface of the track gives way to concrete, and a couple of minutes later you arrive at a junction: keep right here, heading towards Potes. The concrete lane takes you down over the Riega de la Tejera, where you bear left, passing the Sierra de Anjana *orujo* (a local type of firewater) factory on the left before emerging onto the N621 (**3h55min**). Turn right along the road, which will take you back to the Hostal Picos de Europa, where you started the walk, at **4h**.

2 BEGES (PUENTE LA LLAMBRE) • INVERNALES DE PANIZALES • COLLADO DE PELEA • INVERNALES DE LA PRADA • ALLENDE • BAR EL DESFILADERO (N621)

Map pages 58-59; photograph of Beges on the cover

Distance: 7.5km/4.5mi; 2h50min

Grade: Easy-moderate, with an initial climb of just under 500m/1640ft up to the Collado de Pelea, followed by a winding descent of some 800m/2625ft down to the N621 near Lebeña. The route is passable almost all year round, as the maximum height attained is only 1000m/3280ft.

Equipment: stout shoes (preferably walking boots), sunhat, cardigan, raingear, picnic, water

How to get there: 🚌 PALOMERA (Tel. 942-88 11 06; Potes-Santander route). Disembark in La Hermida (journey time from Potes about 25min), then take a taxi to Beges (about 6km/3.75mi): ask to be put off at Puente La Llambre, just before the village.
To return: 🚌 PALOMERA (Santander-Potes route): catch the bus in front of the Bar El Desfiladero, opposite the side turning to Allende; journey time back to Potes about 15min.

This little-travelled route crosses the outlying ranges of the eastern massif of the Picos de Europa, passing through two *invernales*, or wintering areas for livestock, en route, and giving you a glimpse into the traditional agricultural life of the inhabitants of these mountains. Rarely will you meet anyone apart from the occasional shepherd, who will always be delighted to stop for a chat, generally about the weather!

The walk begins at Puente La Llambre, which crosses the Río Corvera on the bend in the road just below the village of Beges. Take the track which runs in a southeasterly direction, up the left-hand side of the stream called Riega Panizales, which is often dry and little more than a ditch. Almost immediately, ignore a small path off to the right which follows the left bank of the Río Corvera.

Near the end of the walk, descending the old road to the Desfiladero de La Hermida, you look back to Allende and the crags of Ajero — a favourite venue for climbers from all over northern Spain.

56

Your route ascends between limestone rock gardens on either side of the stream, dotted with spiny cushions of the yellow-flowered bristly greenweed. Within ten minutes, the track becomes much steeper, and the rough limestone underfoot gives way to a section of concrete, the transverse ridges of which are designed to provide grip for the small tractors which are the twentieth century's 'beast of burden' in this part of the world. Behind you is a marvellous view of the terraced meadows above the village of Beges, and you can also see the old mining track which zigzags up towards the Picos de Macondiú (see Alternative walk 9).

By **25min** the track has levelled out somewhat and the concrete disappears. Soon the limestone outcrops give way to extensive walled meadows, dotted with stone-built barns, as you enter the Invernales de Panizales, where you encounter another short steep stretch of concrete, and the track veers left, away from the Riega. There is a spring on the right here (**40min**).

At about **50min**, ignore a turn-off on the left, which leads only to a barn, and immediately after this, disregard a narrow path down to the Riega on the right. A few minutes later, a stream crosses the track, and you arrive at a cluster of barns, where you go straight ahead. Shortly after, you arrive at a junction: here take the bulldozed track which goes straight on, slightly to the left,

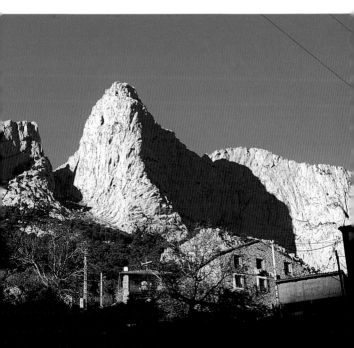

ignoring a grassy track on the right. Follow this new track as it zigzags up through moorland and rough pasture, keeping an eye open for the griffon vultures, short-toed eagles, choughs and ravens which frequent this open landscape.

At **1h25min**, an older track joins yours from the left and below, just before a right-hand bend, and 10 minutes later you reach the high point of the walk, the Collado de Pelea (1002m/3280ft). The view ahead is quite incredible, taking in the whole of the ridge of Peña Sagra, from the triangular limestone 'tooth' of Peña Ventosa directly ahead, to the square-topped bluff of Peña Labra on the horizon far over to the right.

Another bulldozed track branches off to the right just after the col, but your route continues down the hill, where you will find that the earthen track has been resurfaced with coarse limestone chippings. The track zigzags down past a barn surrounded by a walled meadow, with a wall of sheer, almost white cliffs on the right and a wide panorama of the alluvial meadows in the Castro-Cillorigo valley at your feet.

Soon you come to a long, low breeze-block cattle shed with a corrugated-iron roof (**1h45min**): ignore a track which turns off up to right at this point, and follow

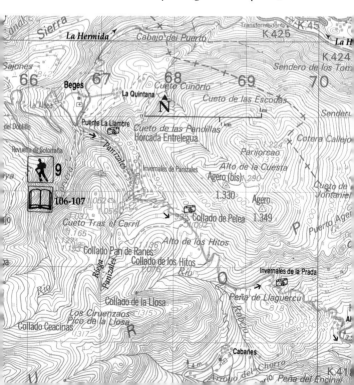

the main track as it veers around to the left, below this building, and then curves back to the right. Five minutes later you reach a junction, where you must turn sharply back to the left (straight on leads to the village of Cabañes). After a few metres, a stream passes under the track: the spring itself lies up to the left, and the water is deliciously cold.

At **2h** keep to the left of a barn in a walled meadow, as the track passes below the crags of Agero, a favourite locality with mountain climbers from all over the north of Spain. As you start descending you soon encounter the first of the Invernales de la Prada, set into the hillside below you on the right. The track describes a curve around this building, then doubles back to the left, leaving another barn on the right of the track. Your route now enters a charming east-facing valley, filled with a mosaic of terraced haymeadows, patches of holm oak forest and jagged limestone outcrops. You negotiate the descent through this valley in a series of sharp zigzags, and soon the pre-Romanesque church of Santa María de Lebeña comes into view far below.

Come to a junction at **2h10min**, where you take the right-hand fork, leading downhill. The route passes through a tract of classic evergreen forest, dominated by

holm oaks, but with a wide variety of other Mediterranean species, such as Lusitanian oak, strawberry tree, sage-leaved cistus, Mediterranean buckthorn and the spiny-leaved climber called *Smilax aspera*.

A few minutes further on, a track turns off to the right into a meadow, but you must follow the main track as it bends round to the left, and continues descending. At about **2h15min**, the track splits in two, and you take the right-hand branch. Over the next ten minutes, ignore two turn-offs on the right, and a track diverging up to the left. By **2h 25min** you should have reached a right-hand bend in the main track, where you ignore a path heading off left past a manure-

Gymnadenia conopsea, the fragrant orchid, is among the more common haymeadow orchids, but it also favours rocky limestone outcrops. You will see it on this walk around the Invernales de Panizales and de La Prada. The lilac-scented flowers bloom from May to July.

heap. At this point you enter an area of gently-sloping dry meadows: ignore all the side turnings which give access to these grasslands and head down the main track into the village of Allende, which you reach at **2h35min**.

The track forms a T-junction with a concrete road, where you turn left (if you go into a small square, to the right of the house opposite, there is a welcome water trough and spring). After a left-hand bend, the road becomes gravel-surfaced and level, passing above the main part of the village.

A couple of minutes later you arrive at another T-junction, where you turn right (the main road out of the village goes left here) onto a tarmac road that descends steeply. A few minutes later, come to yet another T-junction, where you turn left, down the hill. After one minute, the road forks and you keep right (still going down) and then ignore the tarmac drive leading to a house on the left immediately afterwards. You are now on the old road — little more than a track — which was formerly the only access to Allende from the Desfiladero de La Hermida.

Follow this track through fig and walnut groves around a left-hand bend, where it crosses a stream, then ignore all side turnings up into the woods on the right, or into the meadows down on the left (keep an eye out for the persimmon trees which grow in an orchard just to the left of the track here). The last 15m/yds of rocky track, just above the main road, is very steep, as it was cut off when the new road was built. You arrive on the N621 just opposite the Bar-Restaurante El Desfiladero at **2h50min**.

3 LA RUTA DE TRESVISO

Map below; another photograph page 41

Distance: 11.5km/7mi; 5h

Grade: Moderate-strenuous, with a stiff climb of over 800m/2625ft and descent of the same, all on an old mining trail. The route is very popular during the summer and at weekends, so go out of season or during the week. As it is a continual ascent, start early in the day to avoid the heat: only after heavy snow is the top of this route impassable. Walkers who suffer from vertigo may find a short section unnerving. Care is needed on the descent, especially in wet conditions.

Equipment: stout shoes (preferably walking boots), sunhat, sweater, raingear, picnic, water

How to get there and return: 🚌 PALOMERA (Tel. 942-88 11 06: Potes-Santander route). Disembark in Urdón; journey time from Potes about 30min. Or 🚗: park in Urdón.

Short walk: Tresviso — Urdón: 5.8km/3.5mi; 2h. Easy-moderate descent of some 800m/2600ft. Access by 🚗: if friends can take you to Tresviso, do the main walk in reverse and return by 🚌 from Urdón. Alternatively, walk from Tresviso to El Balcón de Pilatos (superb views) and retrace your steps (about 2h20min return).

Although the remote mountain village of Tresviso is now connected to the Asturian enclave of Sotres by road, its main link with the outside world for most of this century was the old mining track which zigzags steeply up from the Desfiladero de La Hermida. But the parish of Tresviso in fact lies in Cantabria, so that when the inhabitants travel to the Monday market in Potes (to make their purchases and sell their cheeses), the trip involves a journey of more than 80km/50mi by road! Although mainly used by walkers in search of a challenge these days, the old trail is still the route taken by the Tresviso postman, who exerts himself daily to deliver the mail ... as well as the village's sole newspaper and any medicines ordered from Potes.

There is no doubt that it is a tough climb, but this is more than compensated for by the splendid views and the feeling of achievement on reaching the top. The route is a spectacular feat of engineering, considering the terrain through which it passes. It is divided into four sets of zigzags, separated by flatter intervals, but the gradient never exceeds 30 degrees — the maximum

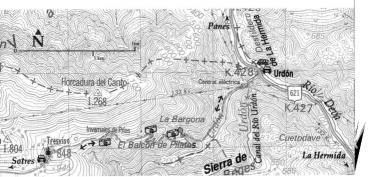

slope negotiable by the heavily-laden ox-carts and mules which once descended with ore from the mines.

Get off the bus or park your car in Urdón, about 2.5km north of La Hermida on the N621. There is a small hydroelectric station by the road here, accompanied by the usual forest of pylons and cables, but you soon leave all this paraphernalia behind. **Start the walk** by heading west up the track which runs to the right of the Caja Cantabria shelter, towards the hydroelectric station. In the early stages, the route is more or less level, and you are following the course of the Río Urdón, one of the cleanest rivers in the Picos, which rushes down from the eastern massif to join the Río Deva at Urdón. Looking back you can see the original arched bridge over this tributary, now overshadowed by a modern one.

About 30m/yds up from road, the track forks. The lower branch leads only to the hydroelectric station, and access is prohibited, so take the right-hand fork, which is still negotiable by vehicles at this point. The screes and cliffs along the path support many wildflowers, including the pale yellow snapdragon *Antirrhinum braun-blanquetii*, the deep purple toadflax shown on page 113 — *Linaria faucicola* — which is endemic to the Picos de Europa, and Mexican fleabane, a trailing, non-native species with daisy-like flowers. Once past the hydro-electric station, you can see the route of the pipeline which brings water surging down from the canal above; here it is buried in a channel cut into the limestone.

In **5min** you cross the Urdón, after which the track narrows and the trail proper begins. About 30m/yds past the bridge, pass a tiny path zigzagging up to the left which leads up to the canal (a sign painted in black on the cliff indicates this, and that the main trail leads to Tresviso). The sunny flank of the river gorge through which you are walking provides an sheltered habitat for such thermophilic species as fig, bay laurel, holm oak and Mediterranean buckthorn, with the shadier cliff faces supporting maidenhair and hart's-tongue ferns, leafless-stemmed globularia and the blue-leaved petro-coptis, the latter unique to the Picos de Europa. Dippers and grey wagtails are commonly seen along this stretch of river, and it is also home to the bizarre Pyrenean desman — a large water 'mole' with a trumpet-shaped nose and a long, laterally-flattened tail — but it is a shy, largely nocturnal beast and sightings are extremely rare.

After **15min**, cross a tiny arched bridge over a

tributary of the Urdón, which is barely a trickle in the summer. Almost immediately, you cross the Urdón itself again, after which the trail starts to climb rather more steeply. The rare subtropical fern *Woodwardia radicans*, a Tertiary relic, grows on the left-hand side of the river here; the fronds may reach some 2.5 metres in length.

Looking back down over the route, from the top of the third set of zig-zags; the triangular peak in the middle distance is Cuetodave, with the looming bulk of Peñarrubia in the background.

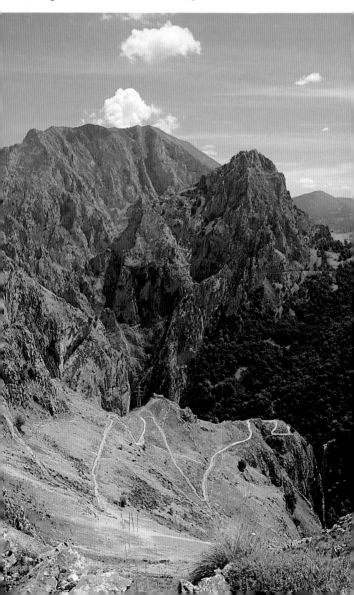

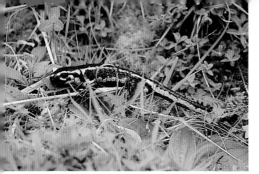

The eye-catching black and yellow fire salamander (Salamandra salamandra) can often been seen during summer thunderstorms.

Soon you come to the first set of zigzags, leading you away from the river. You can see where irresponsible walkers have been cutting the corners, eroding the trail edge and provoking the disintegration of the route; *please follow the original trail at all times.* This south-facing slope is something of a sun-trap, such that the screes alongside the trail are home to an interesting flora, including fringed pink, sticky flax, pitch trefoil, yellow rattle and viper's bugloss, which in turn attracts a wealth of butterflies on sunny days — cleopatras, fritillaries, coppers, blues and hairstreaks. As you ascend, you can look back into the Urdón gorge below and to the left.

By **30min** you will have come to the top of this handful of zigzags, after which the trail levels out a bit and passes through a shady area of figs and walnuts. It is but a brief respite, however, as the second series of zigzags soon appears. This is possibly the toughest part of the route, snaking up a second side gully of the Urdón, known locally as La Bargona. Unfortunately the trail is rough underfoot these days; the walled edges have succumbed to erosion caused by hikers taking short-cuts.

After what seems like a lifetime, but is in fact only about a quarter of an hour, you will have climbed out of the floor of the gully and be traversing the eastern side of it, off the scree and back on the stepped trail (**50min**). If you suffer from vertigo you might find this section a little unnerving, as there is a precipitous drop on your left. On the far side of the Urdón gorge you can see a grassy col at the left-hand end of the Sierra de Beges: this is where the photograph on the famous postcard of the whole Tresviso route was taken from. You can also make out the line of the hydroelectric canal, which inexplicably seems to run uphill from this vantage point.

At about **1h05min**, you round the corner and leave the gully behind. Looking ahead, you can see a good part of the onward route, zigzagging up the mountainside. The cliffs in front of you house a colony of griffon

The large purple-pink flowers and divided leaves of bloody cranesbill (Geranium san-guineum) flourish in meadows and on limestone outcrops.

vultures: you can easily make out the individual nests on account of the guano stains on the rocks. These huge birds are rarely absent from this section of the walk, and often fly so close that it seems you could reach out and touch them. The view to the west up the Urdón gorge is splendid from here, with the triangular peak of Macondiú visible at its head (see Walk 9).

The trail winds around a rocky outcrop and then levels out somewhat before traversing a section of jagged limestone pavement, studded with sharp-spined cushions of bristly greenweed. There is now no shade before you reach the village of Tresviso. After about 10 minutes, the trail splits in two, but both branches lead to a prominent pylon on the edge of a precipice: the right-hand fork is better underfoot. This pylon, reached five minutes later, is situated on a grassy plateau known as El Balcón de Pilatos, and is a super place from which to absorb the panorama. Nottingham catchfly, bloody cranesbill (see above) and Pyrenean toadflax all abound here, attracting butterflies such as the iridescent Adonis blue shown overleaf. You may also be lucky enough to catch a glimpse of Schreiber's green lizard (the males distinguished by their massive blue heads and lime-green bodies), or come across a fire salamander: this generally nocturnal creature (illustrated above left) can often be seen in these high limestone areas or in gorges, particularly after summer thunderstorms.

Now you embark on the third set of zigzags. There is plenty to see as you climb, from griffon and Egyptian vultures soaring overhead, to black redstarts, rock buntings, blue rock thrushes and both Iberian and common wall lizards lurking among the rocks. At about **2h05min**, you encounter a telegraph pole on the corner of the track, and shortly afterwards find yourself following a line of pylons along a flatter section of the route, flanked with meadows and limestone rock gardens. Soon the village of Tresviso comes into view ahead, although it is still further away than it looks.

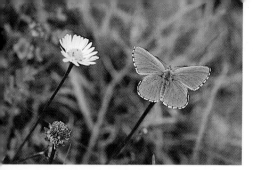

Top: An Adonis blue butterfly alights on a daisy. Below: A male midwife toad with eggs. Although called the 'midwife toad', it is the male which carries the egg-string wrapped around his hind legs until the tadpoles are ready to hatch. While they are difficult to see, you can hear the 'beeps' of midwife toads calling to one another on warm summer evenings.

You enter the Invernales de Prías at **2h25min**; there is a water trough and spring on the right, but it is often dry in midsummer. Having passed a barn on either side of the track, you start to ascend the last section of zigzags, winding up through the steep meadows above the *invernales*. At the top of these zigzags, at about **2h40min**, the trail becomes a track, used by the mini tractor-trailers which are so useful to the farmers. Choughs, with red beaks, and alpine choughs, with golden-yellow ones, wheel in mixed flocks above the surrounding peaks.

Having arrived at the entrance to the village, you will no doubt want to head directly for Tresviso's only bar! Pass a tiny walled cemetery down on the left, and then arrive at a three-way junction; take the right-hand fork, which goes more or less straight on, climbing quite steeply. This concrete 'road' veers left and then right, before passing a large church on the right, sadly dilapidated owing to a lack of funds. From this point you can see the bar over to the left, and you arrive at **3h**. The bar is also endowed with a pleasant restaurant overlooking the valley that you have just ascended.

Once refreshed, retrace your steps back to Urdón. The scree on the trail can be loose underfoot, and, if conditions are wet, the smooth surface of the larger, foot-worn boulders may be slippery, so take care on the descent. Arrive back at the N621 at **5h**.

4 SOMANIEZO • ERMITA DE NUESTRA SEÑORA DE LA LUZ • LURIEZO • SOMANIEZO

Map pages 68-69

Distance: 11km/7mi; 4h

Grade: Moderate circular walk with an initial ascent of over 600m/ 1970ft in just 3km, then a gentle descent back to Somaniezo via the village of Luriezo. Most of the walk takes place on well-marked tracks, but snow may make it unfeasible during the winter months.

Equipment: stout shoes (preferably walking boots), sunhat, cardigan, raingear, picnic, water

How to get there and return: 🚗 park in the turning circle at the entrance to the village of Somaniezo (turn off southeast in Ojedo for Cervera de Pisuerga and Palencia on the C627 then, after 3km, turn left for Aniezo). No bus access.

T his walk follows an old pilgrims' route up to the Ermita de Nuestra Señora de la Luz (Chapel of Our Lady of the Light), situated below the 'holy' peak, Peña Sagra. The venerated image of the Virgin is only about 30cm/12in high, for which reason she is commonly called *La Santuca*, 'the little saint'. So venerated is *La Santuca* locally that she has several feast days dedicated to her each year. On 24 June and 8 September many people make the pilgrimage up to the chapel to celebrate mass and picnic *al fresco*, followed by a *fiesta* with live music in the village of Somaniezo on the evening of 8 September.

But perhaps the best-known event involving *La Santuca* is in the spring: on 24 April, when often there is more than a metre of snow underfoot, the faithful retrieve the Virgin from her chapel and bring her down to Aniezo. Nine days of worship follow, after which *La Santuca* is the focal point of a procession — one of the longest and oldest in Spain — on the second of May. She is carried down to Potes and up to the monastery of Santo Toribio, returning to Aniezo the same day, and to the chapel two days later.

The walk begins in the turning circle immediately below the village of Somaniezo. Cross the narrow stone bridge over the Arroyo de Aniezo, whose crystal-clear waters are bordered by huge mossy boulders, and continue up the concrete road to the left, which leads you into the village. The road veers right by a group of old beehives, some of which are little more than hollowed out of sections of tree-trunk, in the traditional style. After a few minutes, you come to a fork in the road: turn right here, following signs 'Camino de Peña Sagra, La Santuca'.

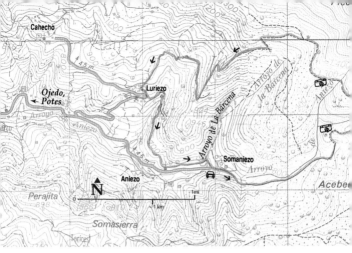

Almost immediately the concrete peters out, and you are walking along a track between old dry-stone walls, through groves of figs, walnuts and cherry trees. After **10min** you cross the Arroyo de Aniezo again, here shaded by hazel coppice and poplars, and start to climb. The edge of Peña Sagra's huge beech forest lies on your right, the contorted trunks of the individual trees testifying to man's silvicultural activities over hundreds of years. The shady banks under the trees support typical acid-loving species such as St Dabeoc's, Cornish and tree heaths, bilberry, holly and Spanish broom.

Shortly, the track levels out somewhat, the forest recedes, and you can see the impressive flanks of Peña Sagra ahead. On the far side of the Arroyo de Aniezo, the south-facing slopes are clothed with Pyrenean oak forest, not beech as on the shady north-facing slopes above you. Stay on the main track, ignoring all side turnings into the adjacent meadows, as it climbs steeply towards Peña Sagra.

By **40min** you have left the forest behind, emerging onto sunny slopes swathed in bracken, gorse and Cantabrican broom. The main course of the Arroyo de Aniezo can be seen over on the left, surging down a gully in a series of small cascades, but your route follows a tributary which veers round to the right.

At about **1h05min**, the track crosses a small, but gracefully arched bridge over a stream which tumbles down the mountainside over a series of stepped boulders. Almost immediately the track describes two sharp zigzags, first right, then left, taking you up to a grassy plateau (**1h20min**). Here you will find welcome shade in the form of a single Pyrenean oak, adjacent to a tiny

stone hut. The panorama across the mountains of the Cordillera Cantábrica and the Picos de Europa, shown on page 70, is quite superb.

On leaving the plateau, the track once again ascends steeply, zigzagging up towards the bulk of Peña Sagra ahead, passing through a small beechwood en route. A few minutes later, after a 90-degree bend to the right (**1h40min**), you come across an area of devastated forest: an avalanche in 1991 tore many beech trees out by the roots — but not a tile on the roof of the chapel (which lay directly in the path of the snow-slip) was touched!

About 10 minutes later, you pass a rather utilitarian cattle shed on the left of the track, with the ruins of a more traditional building just above it. From here, protruding above the trees, you can see the 'flat steeple', crowned with a metal cross, which stands next to the chapel. Keep following the track upwards, leaving this spire on the left. You soon arrive at Nuestra Señora de la Luz, set in a grassy clearing among the heathland and beech forest (**2h**). The view of the Picos de Europa from here is magnificent. A nearby *bolera* is the arena for the 'bowls' competitions which are an essential part of the feast-day activities.

To continue to Luriezo, take the track which passes *below* the chapel. You initially head northwest, but soon curve round to the left, to contour along the western flank of Peña Sagra, high above the valley that you have just ascended. Red and white horizontal stripes are painted on the rock faces along your route. The track crosses a series of small tributaries of the Arroyo de Aniezo, before fording the main gully of this watercourse at **2h15min**. The shaly slopes which border the track support such distinctive plants as ashy cranes-bill and Pyrenean vetch, while the metre-high spikes of white asphodels (photograph page 71) stand out above the surrounding heathland. Looking south and east you can see the true extent of the beech forests of Peña Sagra — ridge after ridge of wilderness, rarely visited by man.

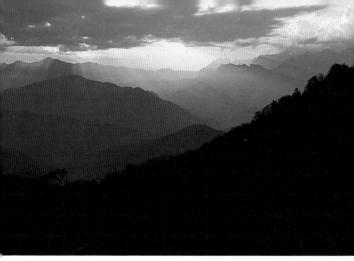

The Cordillera Cantábrica and the Picos de Europa from the grassy plateau above Somaniezo

About five minutes later you find yourself on the top of a ridge separating two valleys, the Arroyo de Aniezo and the Arroyo de la Bárcena. Two large Pyrenean oaks stand sentinel on the corner of a right-hand bend. The track now leads you into an ancient holly forest, the trees festooned with Spanish moss and alive with flocks of tits and finches feeding on the berries. Until fairly recently, it was traditional for the people of Cantabria to decorate their houses with a holly tree at Christmas, but this custom has been largely abandoned following an awareness campaign by the naturalist group ARCA, as many wild creatures depend on the fruits of these trees to sustain them during the winter.

Keep descending until you pass a small dry-stone hut with a turf roof, and a couple of minutes later the track forks (**2h30min**): take the left-hand branch, which leads down the hill (the right-hand fork is marked with crossed red and white stripes). The track now winds down through Pyrenean oak wood-pasture and high level haymeadows; ignore any small tracks diverging from the main route. Eventually you reach a more level section running down the crest of a south-pointing spur, where you ignore a turn-off to the left (marked with crossed stripes) and continue along the spur until you round a sharp hairpin bend to the right (**3h**). The track continues to descend in a series of wide curves, and soon the pantiled roofs of Luriezo come into view.

At **3h20min** you reach an old stone water trough on the right, immediately after which you ignore a path off

to the left and a track to the right. Three minutes later, you come to a concrete road, where you turn left and wind down through this charming, well-maintained village, where many of the houses sport wooden balconies covered with gnarled vines. En route you pass the *potro* (a four-posted shelter with a pulley system, used for shoeing cows) on the left and the church on the right.

At a fork in the road, from which you can see a small water trough up on the left, take the right-hand branch, which passes below an old wooden balcony almost completely concealed by a grapevine. Follow the road as it veers right and emerges onto the tarmac on a hairpin bend in the main Potes-Cahecho road (**3h30min**). There is a bar — it calls itself a *taberna* — on the left here, which has to be seen to be believed! It is a wonderful conversion of a traditional Cantabrian kitchen, with the fireplace downstairs and the eating area on a platform above.

The onward route back to Somaniezo turns left immediately below the *taberna*, just at the left-hand end of the railings which delimit the hairpin bend in the road. Follow this narrow concrete lane for a couple of minutes, past a grove of walnuts on the left and a large house on the right (identifiable by its huge cylindrical bread oven on the wall facing the track). Just past this building the track forks: take the upper, left-hand branch, which curves back below the main part of the village.

Left: Hepatica nobilis, *a member of the buttercup family, flowers early in the year. Right:* Asphodelus albus, *the white asphodel*

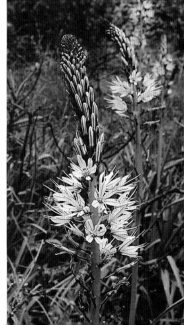

Follow this sandy track to the head of a small valley, ignoring a left turn up to an orange-painted gate. About five minutes later you arrive at a grove of walnuts and sweet chestnuts at the head of the valley, where the track becomes a path and doubles back to the right, passing above a pond with a blue-painted interior. Immediately you come to a fork, where you take the lower, right-hand path. A few minutes later, at a second fork, again take the lower, right-hand branch, which leads you into a mature Monterey pine plantation, with a steep drop down to the right of the path.

Five minutes later you emerge from the pines into an area of haymeadows, and the path becomes a track again. Stay on this main track, ignoring all minor side paths and tracks giving access to the meadows. The village below you, in the bottom of the valley on the right, is Aniezo, and soon Somaniezo (literally, 'overlooking Aniezo') comes into view ahead. At **3h50min**, the track crosses the Arroyo de la Bárcena and you ignore a turn-off up to the left, instead following the main track as it curves round to the right and enters Somaniezo. Ahead of you is a large, square white house, which you leave on your right, and almost immediately you meet a concrete road: turn right here and go back across the old stone bridge to the turning circle where you parked your car (**4h**).

The long ridge of Peña Sagra, seen from the Puerto de San Glorio, where Walk 5 begins

5 PUERTO DE SAN GLORIO • COLLADO DE LLESBA • INVERNAL DE CONJORTES • COSGAYA

Map page 74; additional photograph page 12

Distance: 10km/6.25mi; 2h50min

Grade: Easy; after a short ascent of less than 100m/330ft, the remainder of the walk is a descent of about 900m/2950ft on a good track, (although rather steep in places). This walk is only possible between May and November, as the highest point of the route (Llesba) lies at over 1700m/5580ft.

Equipment: stout shoes (preferably walking boots), sunhat, thick cardigan, raingear, picnic, water

How to get there: ⛟ EMPRESA FERNANDEZ (Tel. 987-22 62 00; Santander-León route) from Potes to Puerto de San Glorio; journey time about 45min

To return: ⛟ PALOMERA (Tel. 942-88 11 06; Fuente Dé-Potes route) from Cosgaya to Potes; journey time about 20min

Alternative walk: Cosgaya — Río Cubo — Cosgaya: 7km/4.4mi; 2h10min; moderate climb of just under 300m/985ft and descent of the same; equipment as above; possible all year round. Access and return: ⛟ PALOMERA (Tel. 942-88 11 06; Potes-Fuente Dé route) to Cosgaya; journey time from Potes about 20min; 🚘 park at the western end of Cosgaya, in a lay-by next to a restored bridge over the Río Deva (saving 15min walking time overall). See notes on pages 78-79.

Although access by public transport is somewhat complicated, this is one of the shorter and easier walks in the Cordillera Cantábrica, traversing the Sierra Mediana and giving you marvellous views of the central and eastern massifs of the Picos de Europa. A short

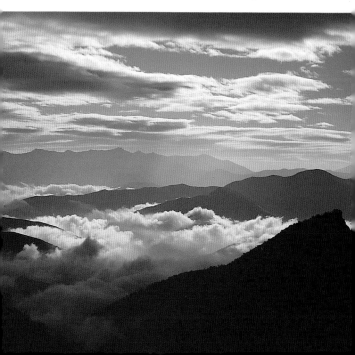

climb takes you to the magnificent viewpoint at the Collado de Llesba, followed by a gentle traverse through rolling upland pastures and a descent through some of the region's most beautiful beechwoods. This walk is especially suitable for a hot summer's day, as the ascent is minimal and the beechwoods provide welcome shade. Clear weather is a must, in order to make the most of the spectacular views.

Leave the bus at the Puerto de San Glorio (1609m/ 5280ft) and after enjoying the view shown on pages 72-73, **start the walk**. Head up the wide gravelly track which leads northeast from the col, directly opposite a small hut which sports a bus-stop sign. This rather eroded track climbs gradually through dry, acid rock gardens and thick scrub composed mainly of tall, yellow-flowered species of *Genista* and Cantabrican

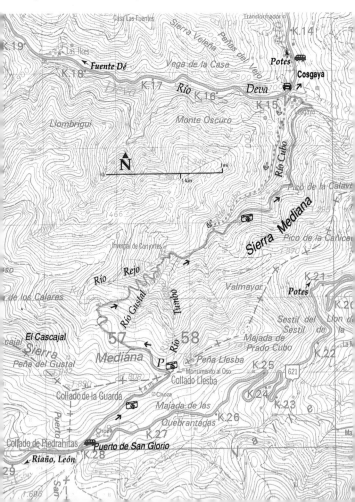

broom, Cornish and tree heaths, ling, bilberry and juniper. You are accompanied by marvellous views of Peña Sagra, Peña Labra and the heart of the Cordillera Cantábrica ahead and to your right. After about 2km, the track turns the shoulder of the hill and delivers you onto the Collado de Llesba (**35min**; *P*1), where the stunning panorama of jagged limestone peaks shown on page 12 opens up before you: Urrieles and Andara. Up the slope to the right of the col is a statue of a brown bear (*Monumento al Oso*).

Keep following the track, narrower now, as it veers left and descends slightly, before rising gently to another col. The vegetation is much as before, with the addition of such colourful species as alpine rose, while the frequent wet flushes host tall spikes of false white helleborine, accompanied by marsh marigolds, heath spotted orchids and the pale green rosettes and deep purple blooms of the insectivorous large-flowered butterwort.

After the col, the immediate scenery changes, and you traverse an area of rolling pastures, inhabited during the summer months by herds of cattle and horses. Great yellow gentians (see page 87) abound here, the bitter roots of which were once widely used as a tonic and also fermented in the preparation of alcoholic beverages, although collection is now prohibited by law.

The track descends once more, heading towards the beechwoods which scale the slopes from the valleys down on your right. At **45min**, ignore a grassy track which splits off to the left. The main track keeps dropping as it swings round to the left, before describing a broad U-bend to the right. Stay on the main track, which has been 'improved', ignoring a faint left-hand fork at **55min** (the old track). As the track performs an abrupt hairpin turn to the left, you drop into the upper levels of the beechwood, here mixed with pioneer species such as birch and rowan. A couple of minutes later, the stony, abandoned track passed at 55min enters from the left.

At **1h** you arrive at a new breeze-block and corrugated-iron cowshed on the left, as the track swings to the right once more. Arriving at a distinct junction less than a minute later, ignore the left-hand fork and keep heading straight on, down the hill. Here the ancient beech trees are multi-stemmed as a result of repeated coppicing, their distorted trunks shrouded with mosses and lichens.

Five minutes later the track traverses another area of

pasture, surrounded by beech and holly forest and dominated by the north face of Peña Llesba, its conglomerate rock concealed beneath a layer of greenish lichens. At the far side of this clearing, the track veers to the left and passes a stone-built barn with a corrugated-iron roof (**1h10min**). There is a spring-fed water trough on the far side of the barn, should you need to fill your water bottle.

The track now starts to zigzag down the forested watershed between the Río Gustal and the Río Rejo, both of which are tributaries of the Río Cubo. Stay on the main track, ignoring the old route which can still be seen in places as it takes a more direct line down this steep watershed, and keep an eye out for the many red squirrels which inhabit these beechwoods.

By **1h35min** the track has dropped to the level of the Río Rejo, and you pass a smaller track which forks off to the left, fords the stream and heads up to the Invernal de Conjortes on the far side (an ideal place for a picnic, although the building itself, at the top of the grassy clearing, is now in ruins). The main route carries on zigzagging down the hill, with the Rejo on the left; ignore all small side turnings which head down to the river.

At **1h45min** the track crosses the Río Gustal, coming in from the right; iron railings on either side prevent vehicles from inadvertently slipping into the gully. Immediately after the bridge, ignore a track which heads up steeply to the right. A minute or so later, cross another river — the Tumbo — which flows over the track on its way to join what is now the main body of the Río Cubo, down on the left. By now the track has levelled out somewhat, and the beechwoods have receded from the margins, making for pleasant walking through sunlit grassy clearings, accompanied by the sound of running water.

Five minutes later, you ford another (unnamed) tributary of the Cubo as it flows across the track, and then ignore a right-hand fork which heads steeply upwards. Immediately after this, a narrow grassy track drops down towards the Río Cubo, on your left (**1h55min**); *this is where the Alternative walk joins the main walk.*

Your route now contours around the western flank of the Sierra Mediana as it heads towards Cosgaya, crossing a number of tributaries of the Río Cubo en route. The river itself is now far below, at the bottom of a sheer, beech-clad slope on the left, with a luxuriant under-

storey of ferns and mossy boulders. The view ahead is quite breathtaking, with a castle-like formation of limestone on the far side of the river standing out sharply against the backdrop of the Picos de Europa in the distance. Lower down, as the valley opens out in the setting shown below, the view behind you is dominated by the almost conical peak of El Cascajal.

The village of Cosgaya comes into view far below at around **2h15min**, as the beech forest gives way to scattered stands of Pyrenean oak, interspersed with dry rocky areas vegetated with spiny clumps of Spanish broom and round-headed thyme (the white-flowered, highly fragrant species cultivated for culinary purposes). Stay on the main track, ignoring all the indistinct side turnings.

The track bends to the right, into the neighbouring valley of the Arroyo Quintana, and starts to descend towards Cosgaya, although the village is concealed from

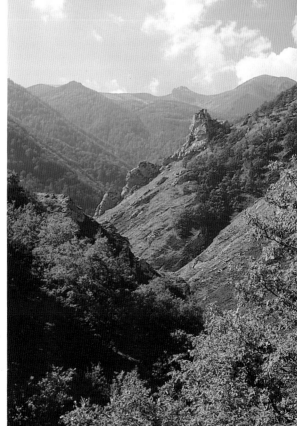

Looking back up the Cubo Valley to the conical peak of El Cascajal

You will see the marsh marigold (Caltha palustris) on wet sections quite early in the walk.

view by a dense belt of young Pyrenean oaks. At **2h30min**, the track emerges into an area of fenced fields, and a minute later, a wide gravelly track comes in from the right: here you turn left, following the track down to the tarmac at the entrance to the village (**2h 35min**). To reach the main road, follow the tarmac as it zigzags down through the houses, ignoring all the side turnings. You will pass a water trough on the left, then a road forking off to the right, signposted 'Apartamentos La Hornera'. Leave the church on the left a couple of minutes later and, as the road swings left, you will see a ruined chapel, also on the left, which is topped by the foliage of an enormous fig tree.

At **2h40min**, come to the last hairpin bend to the right before the main road: here a track forks off to the left, *which is the route taken by the Alternative walk.* On reaching the main road, turn right and head into the main part of the village of Cosgaya. The bus stops in front of the Hotel El Oso (**2h50min**).

ALTERNATIVE WALK

Start the walk where the bus stops in front of the Hotel El Oso, heading through the village of Cosgaya in a southerly direction. In under **10min**, just past a large rock outcrop on the left, turn left up a road signposted 'Cosgaya 0.2km'. The Río Cubo, which you are going to follow upstream during the first part of the walk, is down on the right. At the first hairpin bend to the left, take the track forking off to the right (more or less straight on). Immediately you encounter a fork: take the left-hand branch, through meadows, apple orchards and walnut groves. At **15min** come to a T-junction and turn right, then immediately ignore a grassy track forking up to the left. Pass a ruined mill-house and water tank on the

Globeflowers (Trollius europaeus) *thrive along stream margins all around the Picos de Europa.*

right; then, a minute later, cross the Río Cubo on an arched stone bridge. The track forks immediately, and you turn left, parallel with the river.

Your route climbs through open rocky terrain studded with cushions of Spanish broom and Cornish heath. At **20min**, an eroded path leads off up to the right, but carry straight on along the track, ignoring any small side paths. At **25min**, a track comes in from the right: keep straight on, still climbing gently. The dry rock outcrops on the right support a multitude of ferns (rusty-back, wall-rue and maidenhair spleen-wort) as well as spikes of small-flowered foxgloves, and cushions of rockroses and Pyrenean germander. Tall hazel and dogwood coppice lines the edges of the river, with Pyrenean oak forest on the far side; by **35min** this has given way to beechwoods. Large limestone out-crops, frequented by crag martins, tower above you on the right-hand side. (Where the track becomes flooded, with marsh ragwort, brookweed and several species of mint, take the narrow path along the top of a bank between the track and the river.) Pyrenean oakwoods, with a dense understorey of tree heath and flowering greenweed, replace the open vegetation on your right.

The track eventually narrows into a wide path and crosses the Río Cubo again on another stone bridge (**1h**), then winds up under the beeches — while the river drops in a series of small cascades and pools down on the right. Emerging from the beech, the path appears to double as a streambed, as it passes a log and turf bridge crossing back over the river on the right, then climbs to meet a large track (**1h15min**). This is the 1h55min-point in the main walk: turn left and follow the notes on page 76 to return to Cosgaya via the higher route, with fine views of the Picos de Europa. You arrive in **2h10min**.

6 FUENTE DE (CABLE CAR) • REFUGIO DE ALIVA • INVERNALES DE IGUEDRE • ESPINAMA • PIDO • FUENFRIA • FUENTE DE

Map pages 82-83

Distance: 14km/8.75mi; 4h

Grade: Moderate; a short ascent of less than 100m/330ft, followed by a long descent of 1050m/3445ft to Espinama, then a further ascent of some 300m/985ft and a final descent of about 100m/330ft on the return to Fuente Dé. Almost the whole route follows a wide track (rather steeply in places). Between November and May, much of this route may be snowbound: check with the staff of the cable car station in Fuente Dé regarding conditions at the top.

Equipment: stout shoes (preferably walking boots), sunhat, thick cardigan, raingear, picnic, water

How to get there and return: 🚌 PALOMERA (Tel. 942-88 11 06) from Potes to Fuente Dé; journey time about 45min. Or 🚗: park at Fuente Dé.

Short walk: Fuente Dé (cable car) — Refugio de Aliva — Invernales de Igüedre — Espinama: 10km/6.25mi; 2h25min. Easy; access, equipment and season as above. Follow the main walk as far as Espinama. To return: 🚌 from Espinama to Potes (PALOMERA; Tel. 942-88 11 06); journey time about 40min. Or take a taxi back to your 🚗.

Alternative walk: Fuente Dé (cable car) — Refugio de Aliva — Puerto de Pembes — Peña Oviedo — Mogrovejo — Los Llanos: 15.5km/9.7mi; 3h45min. Moderate; an initial ascent of less than 100m/330ft followed by a very long descent of 1350m/4430ft. Access, equipment, season as above. To return: 🚌 from Los Llanos to Potes (PALOMERA; Tel. 942-88 11 06); journey time 15min, or telephone for a taxi at the bar in Los Llanos, to take you back to your car. Notes on pages 87-89.

This is perhaps *the* classic walk on the south side of the Picos de Europa, starting with a thrilling cable-car ride that takes you up almost 800 metres in just over three minutes. The shattered limestone landscape at the top is not only stunning scenically, but is also home to a

Tesorero, from the start of the walk

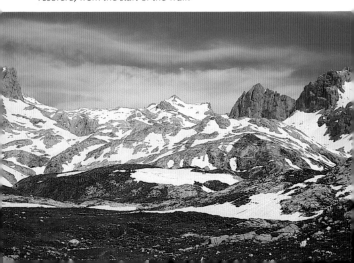

The spring pasque-flower (Pulsatilla vernalis) is at home on these limestone crags.

classic alpine flora and fauna. Early in the year, spring and trumpet gentians (see page 91), Asturian jonquils, dog's-tooth violets, spring pasque-flowers (shown above) and a wealth of saxifrages are on offer, later in the year to be replaced by botanical gems such as Cantabrican bellflowers, Cantabrican houseleeks (see page 87) and the tiny columbine shown on page 109 — *Aquilegia discolor*, endemic to the Picos de Europa.

The more visible fauna includes both choughs and alpine choughs, griffon vultures, snow finches and alpine accentors, as well as chamois, and you might even catch a glimpse of the elusive wallcreeper. The descent from these high rock gardens takes you through the Puertos de Aliva — montane pastures grazed by cattle, horses and sheep in summer — and then through the meadows and forests of the Nevandi river valley down to Espinama. From here, you cross the Río Deva, pass through the village of Pido, and climb through superb limestone meadows and beech forests before dropping down to Fuente Dé once more.

When you emerge from the cable car, be sure to take in the spectacular panorama from the viewing platform nearby; if you are lucky you may catch the famous *mar de nubes*, literally a 'sea of clouds', from which the surrounding peaks stand out like islands. Only one track departs from the upper cable car station, in a more or less northerly direction. **Start the walk** by following this track towards the bulk of Peña Vieja, which at 2613m/8570ft is the highest mountain in Cantabria. On the horizon over on your left rises the conical peak of Tesorero (2570m/8430ft; photographs opposite and page 84), which marks the junction of the provinces of Cantabria, Asturias and León in the Picos de Europa.

Having climbed gently for some **20min**, come to a junction and keep right, which takes you to a col with a splendid view to the east over the Puertos de Aliva, and from where you can see much of the route ahead winding through the pastures below. Start the descent, taking

care as the surface of the track is rather loose in places. Your route winds down past the Chalet Real, on the left, which was the former hunting lodge (for chamois) of the royal family at the beginning of the century, when such activities were still permitted in the Picos.

By **1h05min** you reach the Refugio de Aliva; the original buildings were destroyed by fire and the replacements seem to have more in common with a luxury hotel than a mountaineering hut, but it is still a welcome watering hole in high summer! Looking back you can see the impressive eastern face of Peña Vieja.

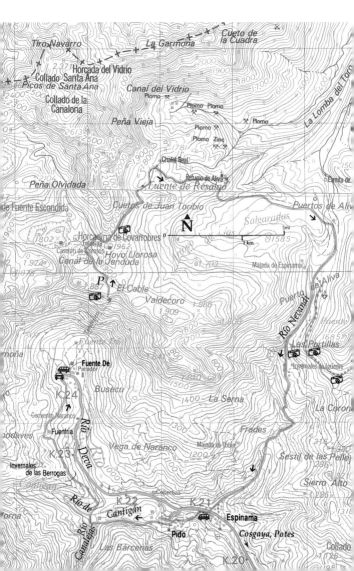

Take the right-hand fork in the track which leads into the refuge enclosure, and walk between the buildings to emerge on the far side. Here turn right and start to descend once more, in the setting shown on pages 88-89. At **1h25min** ignore a left turn to an artificial irrigation pond. Five minutes later, when a track joins from the left, keep right. A few minutes later you arrive at another junction, where you again keep right (more or less straight on), now heading almost due south.

At **1h35min**, the track forks: go right downhill. *(The Alternative walk turns up to the left here.)* In under 10

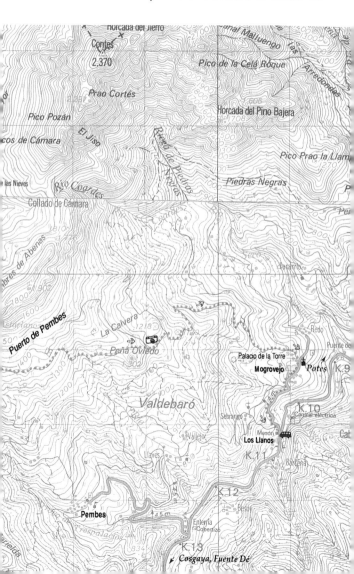

minutes you cross a cattle grid which confines the live-stock to the summer grazing area, and then pass through a narrow defile marked by columns on either side of the track, Las Portillas ('Gates') de Aliva. Almost at once, the whole of the Río Nevandi valley opens out before you, with the bulk of the Cordillera Cantábrica, topped by the volcano-shaped peak of Coriscao, dead ahead.

Within the first 10 minutes of the walk, you look forward along the track to the conical peak of Tesorero in the distance.

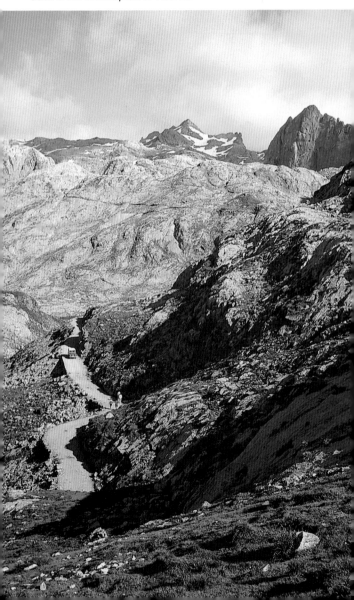

Zigzag down the wide track into the Invernales de Igüedre — pantiled barns surrounded by meadows, where the cattle spend the early part of the winter before descending to the valley during the most severe weather. At **1h50min**, having passed several of these barns, you may be pleased to find a water trough and spring to the left of main track. Ignore the lesser track that diverges off to the left here.

The track now descends in a series of wide zigzags to the village of Espinama. Several smaller tracks lead off into the surrounding meadows, but stay on the main track until you come to the first houses. Not far beyond them, you come to a fork in the track, marked by a water trough in the centre. Here turn right, and emerge onto the main road just to the right of the Hostal Nevandi (**2h25min**). *This is where the Short walk ends.* (If you feel unable to continue back to Fuente Dé on foot, and have parked your car at the cable car station, you might consider taking a taxi.)

There are plenty of bars in Espinama, so after refreshing yourselves, cross the road and turn right. After about 20m/yds, take the track that leads down to the left (in front of the bar/restaurant Vicente Campo). Pass between a water trough on the right and a large pale-blue house, with an impressive stone-carved coat of arms, on the left. Ignore a track down to the left just past this house, and follow the main track as it threads its way through the houses and drops down towards the Río Deva on the left.

At **2h30min**, cross the river via an ancient cobbled bridge, festooned with ivy. On the far side, turn right on a path which climbs steeply through the woods, emerging into an area of meadows confined between dry limestone walls a few minutes later, just below the village of Pido. This path takes you to a T-junction with a concrete road just before the first houses at **2h40min**. Turn left here, leaving the houses on your right, then follow the concrete round to the right, past an *hórreo* (a wooden grain store, raised off the ground on stone 'mushrooms' to keep the rats out). The concrete road then veers left again, and emerges onto a tarmac road a minute later.

Here you turn right along the tarmac, arriving at a fork in the road at **2h45min**. Take the upper, left-hand branch, ignoring a track which turns left just before the school. The road is more or less level here, with iron

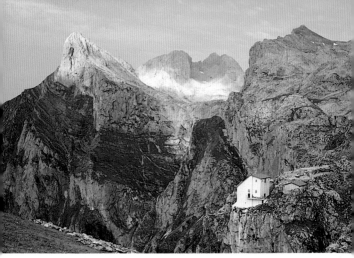

The upper cable car station, with Peña Remoña on the left

railings on the right to prevent vehicles from leaving the road and plunging into the houses below. Two minutes later, the tarmac gives way to concrete once more and the road forks again. This time, take the right-hand, lower branch, and a minute later you will arrive at a confusing crossroads: take the left-hand concrete road which runs uphill, and follow it as it bends around to the right, ignoring a sharp left turn almost immediately after the junction.

At **2h50min**, the concrete ends and a track joins from the left. Go straight on, following a gravelly track past a couple of old barns on the left. Two minutes later, another, wider track joins from the left: carry straight on once again, following the line of the electricity and telephone cables if in any doubt. Pass a water trough and spring on the left.

Stay on this main track for about 10 minutes; it climbs gently at first and then levels out. Over on the right is the superb natural amphitheatre of Fuente Dé, with the upper cable car station perched on the rim. At **3h** you arrive at the goats'-cheese factory of Peña Remoña on the right. Immediately past these buildings ignore a track off to the left, then cross the Río Canalejas and ignore another track off to the left, following the main track as it bends around to the right. Pass two more turn-offs on the left before the main track crosses a second river, this time the Río de Cantigán (**3h10min**).

About 30m/yds after the bridge, take a grassy track which diverges from the main track and leads up to the left: ignore all the side turnings into the adjacent

meadows and stay on this track as it climbs through superb meadows, filled with orchids, and patches of beech forest. At **3h25min**, a track joins from the left, and five minutes later you arrive at a crossroads and carry straight on. A steep climb through the beech forest follows, until at **3h45min** a barn comes into view on the right: a sign tells you that it is Fuenfría.

A couple of minutes later, you emerge at a T-junction with a much larger track, with a water trough and spring opposite. Turn right here and follow this 4WD track until it joins the road at the turning circle just above Fuente Dé (**4h**). Steps on the right lead down to the cable car station, the cafeteria and the car park. The bus back to Potes leaves from the Hotel El Rebeco, just below the cable car station.

ALTERNATIVE WALK

Follow the main walk as far as the **1h35min**-point, then take the left fork which climbs gently to an orange-painted metal gate (**1h45min**). From here there are splendid views of the conical peak of Coriscao (2234m/7330ft) and the Puertos de Salvorón to the south, and of the pantiled roofs of the Invernales de Igüedre, below

Flowers you can hope to see on this walk in summer, from top to bottom: Lilium martagon *(martagon lily),* Gentiana lutea *(great yellow gentian),* Sempervivum cantabricum *(Cantabrican houseleek).*

87

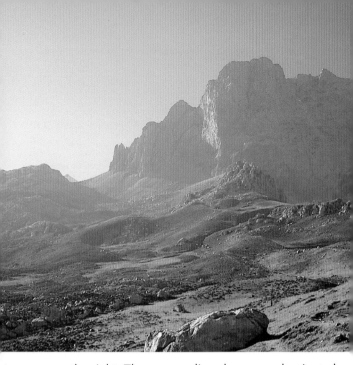

you on the right. The surrounding slopes are dominated by bristly greenweed, gorse and various species of heather.

At a junction reached at **1h50min**, take the higher, left-hand fork, which leads you into the Puerto de Pembes, an area of high pastures studded with great yellow gentians and English irises in summer. Stay on the main track, ignoring all the small cattle paths which diverge into the surrounding pastures. Up on your left, the Cumbres de Abenas form jagged silhouettes against the skyline. The track undulates gently through these high grasslands, with a general downwards trend, until it enters an area of Pyrenean oak forest — an excellent place to see the short-toed treecreeper, nuthatch and great spotted woodpecker. At **2h20min** ignore a track forking off to the right.

Five minutes later, you emerge from the forest onto a col, with a rock outcrop known as Peña Oviedo ahead. Ignore the lesser tracks which branch off on both sides of the col, and stay on the main track, which veers left, leaving Peña Oviedo on the right. The whole of the Camaleño valley now comes into view ahead, dominated by the south-facing walls of Andara on the left. Your route starts to drop down more steeply now, through open heathland and Pyrenean oak scrub, soon

As you start down the track from the Refugio de Aliva, look back to the impressive eastern face of Peña Vieja.

arriving at a second rock out-crop. Here the track once again veers left, leaving the crag on the right. Zigzag down to a third crag at about **2h35min**, which this time you leave on the left, ignoring a grassy track coming in from the left here. A minute later the track forks, but both branches come out in the same place. Descend quite steeply until you come to a fourth crag at **2h45min**. At the junction here, *keep left*, and head back towards the main bulk of the Picos.

Now just follow the track down to Mogrovejo, through meadows, heathland and Pyrenean oak forest: bullfinches and middle spotted woodpeckers are common here, as is the woodland brown, one of Europe's most endangered butterflies. The village soon comes into view below, distinguished by the tower of the Palacio de la Torre at its left-hand end. At **3h05min** the track forks: keep left, downhill. About five minutes later a track joins from the left. At **3h15min** ignore a wide track which forks off to the right. Pass a concrete water tank on the right, then ignore a track coming in from the left. You arrive at the first houses in Mogrovejo at **3h25min**. Follow the concrete road past the Palacio de la Torre on the right, and zigzag down to the church, where tarmac comes underfoot. Here turn right, passing the Bar Mogrovejo (usually shut) on the left. Mogrovejo is a very picturesque village; the wooden balconies on most of its old stone-built houses overflow with geraniums. Stay on the main tarmac road; it leads to the turning circle at the southern end of the village, where there is a water trough ahead (in front of a large house with a glassed-in balcony). Leaving this building on the left, follow the road down to Los Llanos, through dry meadows and sparse holm oak forest. Arrive at the junction with the main Potes-Fuente Dé road at **3h45min**; the bus stops outside the Mesón Los Llanos.

CABRALES AND COVADONGA

The northern reaches

Gentiana acaulis, *the trumpet gentian,*
flowers on the higher limestone outcrops
from April to July.

7 LA GARGANTA DEL CARES: PUENTE PONCEBOS • CAIN • PUENTE PONCEBOS

Map pages 94-95

Distance: 20km/12.5mi; 5h35min

Grade: Easy-moderate; although long, this walk has little in the way of ups and downs except for a 250m/820ft ascent/descent at the beginning/end of the route. The whole walk takes place on a wide trail but, since the route is sometimes a considerable height above the river, those prone to vertigo may find it difficult. The walk is possible all year round.

Equipment: stout shoes, sunhat, cardigan, raingear, picnic, water, *torch*

How to get there and return: 🚌 ALSA (Tel. 98-584 81 33) from Arenas de Cabrales to Puente Poncebos (summer only); journey time about 15min. Or 🚗: park at Puente Poncebos.

Short walk: Caín — Puente Poncebos: 10km/6.3mi; 2h50min. Grade, equipment and season as above. Access by 🚗: if friends can take you to Caín, follow the main walk in reverse and return by 🚌 from Puente Poncebos. The first section of the route is by far the most spectacular, so you could just walk to Puente Bolín and back (1h10min return).

The route through the Garganta del Cares (literally the 'throat' of the Río Cares) is perhaps *the* classic walk in the Cordillera Cantábrica. However, as its fame is steadily escalating, it is perhaps wise to avoid July and August, as well as weekends throughout the year, if you don't want to be exchanging greetings with day trippers the whole time! The trail was constructed by the electricity company Viesgo in the 1940s in order to maintain the hydroelectric canal that runs between Caín and Camarmeña.

Choose a mid-week day in spring or autumn, and you will be rewarded with relative peace and quiet. You might even be lucky enough to see wallcreepers: the Cares Gorge is recognised as being a prime site for these small, ash-grey and cerise birds. Griffon vultures are a more common sight, however, soaring on the thermals which emanate from the defile. The sheltered depths of the gorge enjoy a mild climate, which encourages an essentially Mediterranean flora to flourish, including bay laurel, wild jasmine, strawberry tree, barberry, wild fig and turpentine tree. The more humid overhangs provide a foothold for festoons of blue-leaved petrocoptis — a pink- or white-flowered member of the campion family, which is unique to the Picos de Europa.

The walk begins in front of the Hotel Mirador de Cabrales, which lies just up the hill from Puente Poncebos. Follow this tarmac road, with the Río Cares down on your left and the hotels on the right, almost immediately

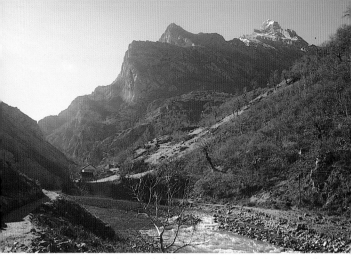

Emerging from the southern end of the Cares Gorge, on the approach to Caín

passing a road under construction to the hamlet of Camarmeña, which hangs among the crags up on the right. Not long after **5min** you come to a short tunnel hewn from the limestone, just beyond which you ignore a path climbing to the right. (This steep, winding path is signposted 'Bar/Comidas' in blue paint on the rock. It also leads to the Mirador del Naranjo in Camarmeña, from where one can admire the buttress shown on page 28 — the Naranjo de Bulnes. Rising to 2519m/8265ft, this sheer-sided mass of limestone was not conquered by man until 1904.)

Where the tarmac gives way to limestone chippings, pass the left turn which leads to Bulnes (see Walk 8), and shortly after you will come to the start of the Ruta del Cares: this is impossible to miss, as three signposts all point up the narrow, rocky trail to the right (**15min**). You now start on a steady climb of some 250m/820ft, leaving the Río Cares far below you on the left. You will have plenty of excuses to stop and catch your breath, as the views are splendid. The gorge is fairly open here, with stunted holm oaks clinging to the sheer rock faces. The cliff opposite is pock-marked with small caves, some of which double as corrals and barns — although from your vantage point, access seems all but impossible. The rocks along the trail here support many different species of fern, including wall rue, rusty-back fern, maidenhair fern and maidenhair spleenwort.

After **40min**, you arrive at a cluster of sombre-looking barns on the left-hand side of the trail, the main one of

which lacks a roof. You have also attained the level of the canal at this point, roofed-over here to prevent it from filling up with scree: you can see the silent, swiftly-flowing water through a small iron gate to your right, just below the barns. The trail forks by this gate: take the upper, right-hand branch and zigzag up past the barns and above the level of the canal.

A final steep haul takes you to Los Collados, at the top of the ascent (**1h**), marked by a group of ruined barns on your right. Looking ahead, you can see the Majada de Ostón, hanging in a valley high above the gorge — as well as the continuation of your route, winding back down into the depths of the gorge, alongside the canal. Start dropping down, passing a curious rock shaped like a clenched fist by the side of the trail. You

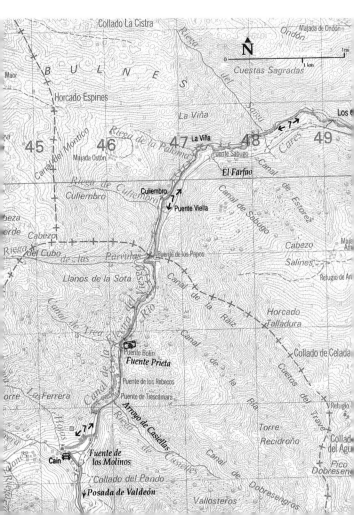

join the canal once more, still covered at this point, but visible through a green-painted iron gate on the right.

At **1h15min** ignore a small path branching off to your left, zigzagging precipitously down towards the river, which you can hear thundering along below. A few minutes later, you pass a barn of modern construction on the right and, looking up, you can see a natural archway in the rock above you. The trail often passes beneath wide overhangs — don't stop to think about the weight of rock poised above you! — which are used as shelter by the multitude of goats which inhabit the gorge, despite the water which continually drips from the 'ceilings'.

At about **1h25min** pass a stone-built hut on your right, by a green sluice-gate in the canal wall, which

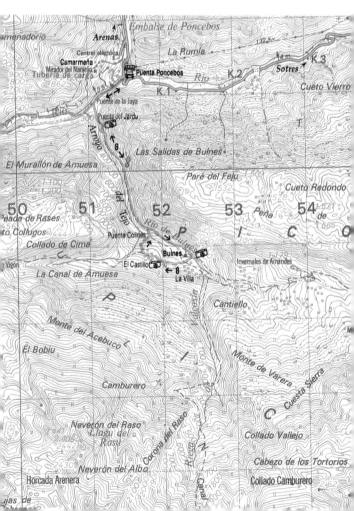

allows for overflow when the river is running high. Then cross a tributary of the Cares: the stream runs over the trail in winter, making it very slippery, so use the small bridge on the right. And although the water is crystal-clear, take note of a red-painted sign which advises you not to drink it.

About ten minutes later, you pass through four rock arches, or short tunnels. Far below, a large tributary of the Cares emerges directly from the rock, on a springline known as El Farfao. You then pass through another arch. At **1h35min**, you enter the Covadonga National Park, by a group of buildings called La Viña: this part of the Picos de Europa is also a Special Protection Area for Birds, as a European Union sign indicates. La Viña is followed immediately by a tunnel and, ten minutes later, after another arch, sheep-dotted meadows appear on the far side of the gorge, hanging high above the river. A tiny, almost invisible path winds up to them. In the bottom of the gorge, a bridge, the Puente Viella, provides access to this path.

At around **1h50min** the trail passes a hamlet called Culiembro: little more than a single house, surrounded by walnut groves and pasture for several donkeys. This remote dwelling, isolated in the heart of the Cares Gorge, is occupied for most of the year. You might also be surprised to see National Park dustbins here, and wonder at the logistics of rubbish collection in such an inaccessible locality!

After Culiembro, the gorge starts to narrow; holm oaks sprout from the sheer rock faces, and you enter wallcreeper territory. The trail rises above the canal, and as you negotiate a tight hairpin, you can see the rushing water through a series of narrow arched 'windows' on the opposite side (**2h**). In the apex of this hairpin, you go through a short tunnel and cross another tributary of the Cares, with a gushing waterfall above you (at least in winter). Five minutes later you encounter a stone barn with a corrugated-iron roof on the left of the trail.

By **2h10min** you are again level with the canal, and you pass a green-painted sluice gate. In the next five minutes, the trail squeezes through two narrow arches in the rock, then the gorge opens out briefly to permit groves of walnuts and lime to flourish on both sides of the route. The flowers of the latter are collected by the inhabitants of Caín for the preparation of an infusion. More dustbins appear at around **2h20min**, from which

point there is an excellent view of the Fuente Prieta waterfall on the far side of the gorge.

A few minutes later you come to the first bridge — a green 'Meccano-like' construction called Puente Bolín. Signs in several languages warn against overloading. From the middle of this bridge, the view up the gorge is stunning — the walls are virtually touching and the gap

The Puente de los Rebecos, high in the Cares Gorge

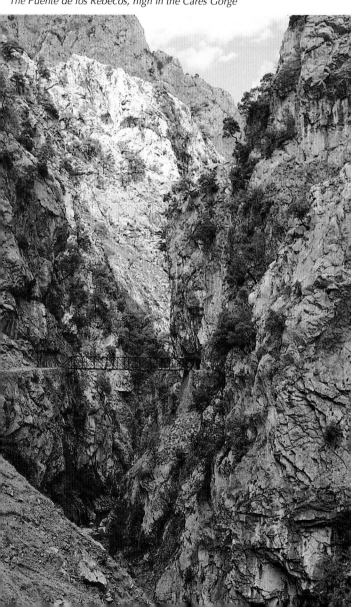

is filled with spray from the canal. Pass through an arch, and arrive at a second bridge — Puente de los Rebecos (**2h30min**; photograph page 97). It has the same design and weight limit as Puente Bolín, but is a fair bit longer. You are much closer to the river here, such that you can hardly hear yourself think for the noise. A few minutes later, you enter the longest tunnel so far (a torch is very handy here) and, as the river and the canal draw closer together, you realise that your destination is close at hand.

At **2h40min**, the gorge widens out as the Arroyo de Casiellas joins the Cares from the left: this is a perfect place to swim on a hot summer's day. On the right here is a complicated sluice system which allows a massive discharge of water back into the river if the level is high. After this brief glimpse of sunshine, you once again enter a long series of tunnels, with only occasional windows. Again a torch is useful, as deep puddles are common and the roof is very low in places.

Just under ten minutes later, at the end of the tunnels, you emerge at the weir which diverts water from the Río Cares into the canal: note the fish ladder here, which assures the Valdeón trout fishermen of their sport. Cross the river again, over the top of the weir, and leave the gorge in the setting shown on page 93. Dippers and grey wagtails accompany you along the sunny trail up the left-hand side of the river.

A wide modern bridge takes you across the Cares one last time at **2h55min**. Ignore the path which continues along the left-hand bank of the river here. Pass two houses on the right and follow the narrow undulating path to the village of Caín (**3h**). Note the old mills on the vigorous springline (Fuente de Los Molinos) on the opposite side of river as you approach Caín. Several bars with restaurants have recently sprung up to cater for thirsty walkers at the entrance to the village, and most offer accommodation as well.

Once refreshed, return to Puente Poncebos by the same route, which involves a short climb of about 100m/330ft back up to Los Collados, before you negotiate the 250m/820ft-descent back to the Hotel Mirador de Cabrales, arriving after **5h35min** walking.

8 PUENTE PONCEBOS • BULNES (LA VILLA) • BULNES (EL CASTILLO) • PUENTE PONCEBOS

Map pages 94-95

Distance: 8km/5mi; 3h30min

Grade: Moderate; although a short walk, the ascent/descent is almost 500m/1640ft, with a *high risk of vertigo on some sections*. Avoid the route in July/August and at weekends throughout the year; feasible all year round, except for immediately following heavy snow.

Equipment: stout shoes (preferably walking boots), sunhat, cardigan, raingear, picnic, water

How to get there and return: 🚌 ALSA (Tel. 98-584 81 33) from Arenas de Cabrales to Puente Poncebos (summer only); journey time about 15min. Or 🚗: park at Puente Poncebos.

Bulnes is the most isolated village in the Picos de Europa, without road access even today. The route taken during this walk is that still used by the inhabitants of Bulnes, many of whom use pack-donkeys in order to transport their artisan cheeses to market, and other goods — such as the unwieldy butane gas-bottles — in the opposite direction. The route winds up the deep river valley of the Arroyo del Tejo and visits both *barrios* (districts) of Bulnes before returning to Puente Poncebos … and civilisation.

Start the walk outside the Hotel Mirador de Cabrales and walk up the tarmac road towards the entrance to the Cares Gorge (see Walk 7), leaving the new road to Camarmeña on your right. In a little over **5min** pass through a tunnel — often occupied by donkeys belonging to the inhabitants of Bulnes. They leave them here while they are doing business in Arenas de Cabrales. Beyond the tunnel the Arroyo del Tejo, a tributary of the Río Cares, is visible over to the left: you can see your route up to Bulnes winding up the left-hand side of this valley.

A couple of minutes later, go past a path on the right which zigzags steeply up to the *mirador* in Camarmeña (it is signposted 'Bar/Comidas'). Almost immediately the tarmac ends, and you will encounter a sign indicating 'Picos de Europa — Camino de Bulnes' where you turn left and head down the trail towards the river, crossing the Río Cares on the Puente de la Jaya at **10min**. The river here is incredibly clear and blue, and there is a perfect pool for swimming down to your right, under an overhang.

The narrow trail is cobbled in places, the stones having been worn smooth by the pedestrian traffic of several centuries. Unfortunately this makes the trail

rather slippery, both in wet and dry conditions, *especially when descending, so take care.* Impressive peaks and pinnacles surround you, riddled with caves and overhangs which provide roosting and nesting sites for birds of prey, including griffon vultures, kestrels and peregrine falcons.

Climbing up from the bridge, you arrive at a barn almost immediately, where the trail doubles back to the right and starts to ascend more steeply. After three or four zigzags, the trail levels out somewhat, and you can look down into the Arroyo del Tejo on the left. The limestone rock gardens on either side of the trail are a blaze of colour in spring and summer, with small-flowered foxgloves, round-headed rampions, Pyrenean eryngo, viper's bugloss and the yellow-flowered monks-hood *Aconitum lamarckii.* The trail is following a line of unsightly, green-painted pylons, which have only been in place since the late 1980s; prior to this time Bulnes had no mains electricity.

After about **15min** you come to the wooden bridge shown opposite, the Puente del Jardu, which takes you across the Arroyo del Tejo. The trail then zigzags up fairly steeply again: *please follow the main route (which is identifiable by its walled edge), without eroding the trail by cutting corners.* From the first bend after the bridge, looking back towards Puente Poncebos, you can see the serpentine path which ascends to Camarmeña and its houses clinging to the almost sheer cliffs, as well as the hydroelectric canal which enters the hamlet from the Cares Gorge (see Walk 7).

By **30min** you have conquered this set of zigzags, and the trail descends almost to the level of the Arroyo del Tejo before snaking its way uphill once more. In all directions you are confronted by pale limestone, in an apparently endless variety of shapes and forms, decorated with twisted limes and hazels, whose roots embrace the living rock. Keep climbing, and eventually you round a bend and can see a good section of the trail ahead, winding up the left-hand side of the gorge carved out by the Arroyo del Tejo.

The route is less steep now, but the lack of shade makes the climb thirsty work. Seasonal streams cross the trail from time to time, creating cascades down to the river below in winter. One such watercourse is so fearsome that it has been diverted over the trail via a concrete chute, and you must pass underneath it. Just

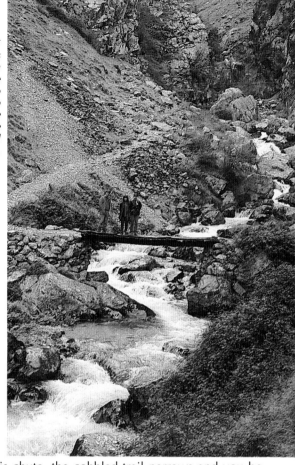

In 15 minutes you cross the Arroyo del Tejo on the Puente del Jardu.

after this chute, the cobbled trail narrows and you become aware that the river is now far below: *there is a real danger of vertigo here.*

After about **1h**, the meadows around Bulnes start to appear up ahead, but there is no sign of the village itself yet. Ten minutes later, the trail briefly enters a narrow gully between two banks of rubbly limestone. Keep left on coming out of the gully, ignoring a small path off to the right (although both routes join up later, the left-hand branch is far easier underfoot).

The El Castillo district of Bulnes comes into view on top of the hill on your right at about **1h20min**, and the trail drops down slightly towards the river again. Here you will encounter several grassy picnic spots by the water's edge — one of which is even furnished with the welcome shade of an oak tree — and a few small waterfalls and pools in the river, which are very inviting on a hot day.

Keep climbing along a slightly braided section of the trail until you come to a wooden bridge across the river (**1h30min**). Known as Puente Colines, this rather rickety structure leads to the narrow path which ascends to El Castillo: *this is your return route.* For now follow the red arrows painted on the rocks here, indicating your trail up to the main part of Bulnes, known as La Villa, *without* crossing the river.

The final section of this trail into Bulnes is more or less level, passing between walled meadows on the right and extensive screes coming down from the foot of the cliffs up on your left. You are always accompanied by the song of the river. Soon the valley opens out and trees start to appear, particularly walnut, sycamore and hazel.

At **1h40min**, stay on the main trail, ignoring a path on the right leading down between two walled meadows to the river. Finally La Villa comes into view, and you realise that many of the houses are virtually in ruins; the emigration of the young folk to the cities (or even just to Arenas de Cabrales) in search of a better standard of living has obviously taken its toll here. Pass the cemetery on the left, and at **1h45min** cross the wooden bridge over the Arroyo del Tejo and enter Bulnes (La Villa). Bar Bulnes is in front of you, and signs indicate the presence of other bars and a youth hostel. The setting is impressive, with sheer walls of limestone on all sides.

To continue up to the higher district of Bulnes, known as El Castillo, you must go back to the bridge across the Arroyo del Tejo and look towards the village. Over to the right, there is a sign saying 'BAR' painted in red on the wall: follow the arrow and go past a map of La Villa (showing the position of the main buildings of interest in the village) attached to the wall of a house on your right. Follow the narrow lane until you have passed most of the houses and barns, except for some ruins on the top of the hill, then take the *second* turn-off on the right. This track takes you past a bar on the right called Casa Guillermina, which sells locally-made artisan cheeses.

The flower-filled limestone meadows of Asturias are a veritable treasure-house for orchids in early summer.

You are now following a cobbled limestone trail which climbs gently through flower-rich meadows. Five minutes later El Castillo comes into view ahead. The trail-side vegetation is very diverse, including Nottingham catchfly, spreading and clustered bellflowers, large-flowered self-heal and betony, as well as patches of bracken and hazel scrub. Just before El Castillo, pass a water trough on the left (**2h**), which normally hosts a healthy population of palmate newts.

You arrive at the first houses five minutes later, and the trail takes you straight through the middle of the village. Again many of the buildings are in ruins. By **2h10min**, having reached the last house on the right, you find yourself standing on the edge of a bluff. From this point you have an excellent view of your earlier trek up the Canal del Tejo, and also of the hamlet of Camarmeña, far below.

The main trail veers left here, and climbs up towards Amuesa, but you must take a small path off to the right, just to the left of the last house. It zigzags down to Puente Colines through abandoned meadows and limestone outcrops. Although fairly steep, this descent is not vertiginous. At around **2h25min** you reach Puente Colines, the bridge you passed during the ascent (at 1h30min). Although it is a little wobbly, you can pick your way across with care, although if you don't fancy risking your neck, you can always wade across the river. Once on the far side, turn left and *carefully* retrace your steps back to Puente Poncebos (**3h30min**).

9 PICOS DE MACONDIU: JITO DE ESCARANDI • VAO DE LOS LOBOS • CASETON DE ANDARA • (POZO DE ANDARA) • JITO DE ESCARANDI

Map pages 106-107

Distance: 16km/10mi; 4h40min (for the 3km return detour to the Pozo de Andara add 1h).

Grade: Moderate-strenuous; a 200m/655ft descent followed by a level section, then a gradual climb of 550m/1805ft and a descent of 400m/1310ft back to where you started. The whole route follows an old mining track, and is easy underfoot. A word of warning: *the higher section of this route is often snowbound between November and May.*

Equipment: stout shoes (preferably walking boots), sunhat, thick cardigan, raingear, picnic, water, compass, whistle

How to get there and return: 🚗 park at the junction called Jito de Escarandi, about 3km east of Sotres, where the road veers left towards Tresviso. No bus access.

Alternative, longer walk: Beges — Horno del Doblillo — Vao de los Lobos — Casetón de Andara — Jito de Escarandi — Vao de los Lobos — Beges: 28km/17.5mi; 8h50min. Strenuous: the complete circuit is only suitable for the fittest walkers, as the total ascent/descent is almost 1200m/3940ft. Access: 🚌 PALOMERA (Tel. 942- 88 11 06; Potes-Santander route). Disembark in La Hermida (journey time from Potes about 25min), then take a taxi to Beges (about 6km/ 3.75mi). On your return to Beges, telephone for a taxi back to La Hermida, in time for your return bus. (The last bus to Potes departs at 19.15 on weekdays and 18.15 on weekends and holidays.) Or 🚗: park in the turning circle at the entrance to Beges. Equipment and season as above. See notes on pages 110-112.

T his superb walk takes you across some of the least-visited limestone terrain in Andara — the eastern massif of the Picos de Europa. Although fairly long, the gradient is never excessive and the whole circuit takes place on a well-marked track, carved out of the living

Moss campion (Silene acaulis) *thrives on the higher reaches, below Macondiú.*

rock in the last century to provide access to the zinc mines in the heart of Andara. Choose a clear day in early summer and you'll be rewarded by breathtaking scenery and an incredible diversity of wildflowers, but best of all, you'll hardly meet a soul.

The walk starts at the Jito de Escarandi, from where you follow the track heading almost due east, leaving a couple of rather unattractive breeze-block huts with corrugated-iron roofs on the right. The surrounding heathland is dotted with the trunks of dead trees and usually occupied by an immense herd of goats. Follow the main track, which zigzags down some 200m/655ft into a grassy hollow known as the Vega del Tronco; 'A Beges', painted on a block of limestone, will reassure you that this is the correct route (**20min**).

You soon enter the beech forest, as the track contours around the Sierra de la Corta for a couple of kilometres. Several grass-covered, little-used trails diverge to both right and left, but stay on the main track until you emerge from the forest onto a heath-covered slope. From here you can see the *majadas* of La Cerezal and La Llama down to the left. *Majadas* are groups of barns where livestock is kept in the summer, surrounded by walled pastures for the cows, sheep and goats whose milk is converted into artisan cheeses. In Beges and Tresviso an exquisite blue cheese — *queso picón* — is prepared from a mixture of milk from all three types of livestock, then matured for up to three months in high-level limestone caves.

Back among the beech trees the track crosses two arms of a stream, the Riega del Torno, before arriving at a junction (**1h10min**): the left-hand fork leads down to the *majadas,* so stay on the upper track. From here, it is an easy 15-minute walk in the cool depths of the forest to the spring and water trough at Vao de Los Lobos (**1h 25min**). Take note of a sharp turn back to the right about 20m/yds *before* the spring; it is your onward route. *(The Alternative walk joins here.)*

Vao is the Asturian version of *vado*, which means 'ford'. The flora here is truly superb in early summer, dominated by hundreds of purple, one-sided spikes of dragonmouth, while the cliff at the back of the spring literally drips with clumps of large-flowered butterwort, an insectivorous plant whose sticky, pale green leaves trap small invertebrates. Fill your water-bottle here; surface water is a rare occurrence on the limestone.

From the spring, retrace your steps 20m/yds to the right turn passed previously (now on the *left*), and follow it up into a cool, shady beech forest, populated by untidy, multi-stemmed trees that sprout directly from crevices in the limestone. Rocky outcrops amid the trees are chock-a-block with trumpet gentians (see page 91), the lilac 'pompoms' of leafless-stemmed globularia, and sprawling clumps of *Linaria faucicola*, a toadflax unique to the Picos de Europa (its tiny, deep purple flowers, shown on page 113, resemble miniature snapdragons). Red squirrels are often seen here, although other denizens of this forest — garden dormice, wildcats, beech martens and wild boar — are more secretive.

Emerging from the trees, the view ahead (shown on pages 108-109) is stunning — dominated by the wedge-shaped peak of Macondiú itself. Here, at about 1400m/ 4595ft, the flora is correspondingly more alpine: low, straggling bushes of bearberry and dwarf juniper are

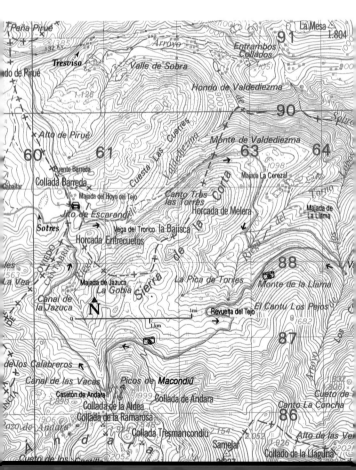

interspersed with velvety sheets of moss campion (photograph page 104), clumps of azure-flowered spring gentians and the delicate blue-tinged, white blooms of *Anemone pavoniana*, another Picos endemic.

Still climbing, you reach a hairpin bend to the left (called the Revuelta del Tejo) at **2h35min**. Here griffon vultures, with wing-spans of almost two metres, ride the thermals overhead, while wheatears, black redstarts and alpine accentors go about their business in the surrounding rocky outcrops. In high summer these rock gardens are populated by woolly-leaved rosettes of *Hieracium mixtum*, a member of the daisy family with yellow flowers, as well as alpine gypsophila, Pyrenean lousewort and the endemic columbine shown on page 109, *Aquilegia discolor*.

Keep winding steadily uphill for almost an hour. On approaching the east face of Macondiú (2000m/6560ft), which echoes with the rifle-shot calls of choughs, you

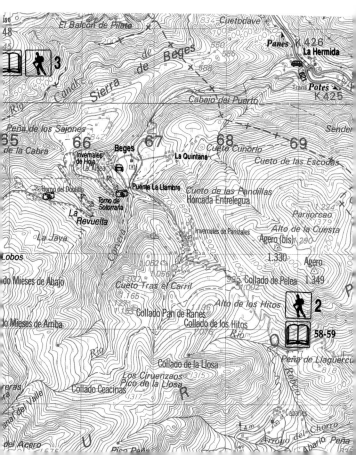

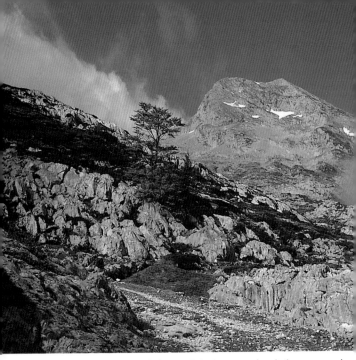

arrive at a junction (**3h30min**): ignore the left turn and follow the main track as it contours round the north face of the peak. Looking north, on a clear day it is possible to see the sea from this point, particularly the estuary at San Vicente de la Barquera, over to your right.

The main track curves round to the left, to pass under the west face of Macondiú, taking you into a blind valley known as the Canal de las Vacas. At the head of this valley lies the Casetón de Andara (**3h50min**), a rather unattractive building which was formerly the headquarters of the mining company but has recently been converted into a refuge for walkers and mountaineers. Just before you reach the refuge, a wide, stony path diverges up to the left: *this is the route to take for the detour to the Pozo de Andara, described below.*

Detour: The Pozo de Andara is one of the most beautiful picnic sites in the eastern massif of the Picos de Europa. Take the scree-covered path mentioned above, about 50m/yds *before* you reach the Casetón de Andara, and zigzag uphill; ignore a path off to the right which leads directly to the refuge before the first hairpin bend to the left. The second hairpin bend, to the right, lies adjacent to the west face of Macondiú: about five minutes after this bend, ignore a path down to the right, which also

108

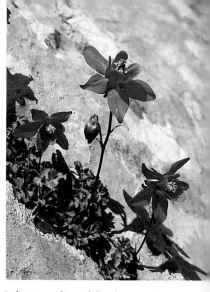

Left: Macondiú and the alpine rock gardens, just as you emerge from the beech forest. Above: Aquilegia discolor, an endemic columbine

leads back down to the refuge. Keep an eye out for some of the rarer scree plants in the Picos as you wind up through the mining spoil heaps, including yellow mountain saxifrage, spoon-leaved candytuft, Pyrenean bedstraw, alpine toadflax and the exquisite alpine snowbell. In about **20min** you arrive at a level area known as the Collada de la Aldea, with a walled pond on the left: go straight on here, ignoring the trail up to the left. A couple of minutes later, ignore another trail branching off to the left, and start descending, following a wide gully on the left of the track. Ignore a path which forks off up to the right about a minute later. The wide path takes you down to a lush marshland, ringed by peaks: the Pozo de Andara (**30min**). There are small, spring-fed pools at either end of the marsh, which are all that remain of what was once a glacial lake: unfortunately the base of the lake was perforated during the extensive mining activities in the area. Today the marshland is a favourite haunt of water pipits, wheatears and alpine newts, as well as clouds of the rare Gavarnie blue butterfly in late summer. In the rock outcrop at the far end of the marsh, you will discover a veritable labyrinth of small cave dwellings, formerly used by the miners. Retrace your steps to rejoin the main route, arriving back at the Casetón at **1h**.

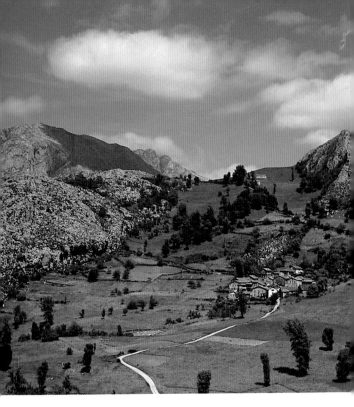

To complete the circuit to the Jito de Escarandi, leave the Casetón de Andara on your left and follow the track around the head of the valley, passing under the rails of an old mine-truck system. The flora here is different again: look out for cushions of yellow and purple saxifrage as well as amplexicaule buttercups, distinguished by their white flowers and broad, grey-green leaves. On the way you pass the Majada de Jazuca, down on the right, before arriving at the Jito de Escarandi (1290m/ 4230ft) after **4h40min** walking.

ALTERNATIVE WALK

Start by following the main track through Beges, leaving the village's only bar — Mesón San Carlos — on your left. Once clear of the houses, you can see the supporting walls of the route ahead zigzagging up the slope above you. At first the track leads through terraced meadows, teeming with yellow rattle, spreading bellflowers and several species of orchid, before entering a zone of low-level limestone rock gardens. In early summer the limestone outcrops alongside the track are decked out in a multitude of colourful rock plants, including fairy

La Quintana, near Beges, is a classic example of a village in Liébana: closely-packed houses, built back-to-back to save on building materials, surrounded by the haymeadows which are the backbone of the beef-rearing economy in the Picos de Europa. Note too the cylindrical ash trees, lopped and topped every two years to provide autumn fodder for the cattle, kindling, and multi-purpose stakes (see photograph page 55).

foxglove, spring squill and scrambling gromwell. Still climbing, you reach the first hairpin bend to the right (the Torno de Sotorraña; 750m/2460ft) after **40min**. Looking down, you have a superb view of Beges sprawled below, as well as of the tiny hamlet of La Quintana (see above) huddled on the opposite slope. Beyond La Quintana rises the sheer wall of Peñarrubia, on the far side of La Hermida's gorge. Egyptian vultures, unmistakable with their pure white, black-tipped wings, can often be seen soaring *below* you from this point.

The track continues to climb, leading you to the Invernales de Hoja (**1h**), a small cluster of barns which are occupied by the cows as they return from the high pastures at the onset of winter. Just past these barns, ignore the track off to the right, which leads onto the top of the Sierra de Beges, and continue along the main track, which loops through walled meadows studded with clumps of white asphodels. Round a second hairpin bend to the right, known locally as La Revuelta, and keep on climbing, ignoring a sharp turn-off back to the left and passing two more barns on your left.

Just as the track starts to flatten out, you arrive at the

Horno del Doblillo (1050m/3445ft) down to the right (**2h05min**). Now in ruins, these *hornos*, or 'ovens', were formerly used for roasting the raw zinc minerals (sphalerite and hemimorphite) brought down from the mines by ox-cart. From here, there is a superb view northwards to the Sierra Cocón, as well as of the upper part of the precipitous, serpentine trail which links Urdón, in the bottom of La Hermida gorge, with the remote village of Tresviso (see Walk 3).

Just past the ruins, the valley to the right drops away precipitously in a series of crags known as Salto de la Cabra ('goat's leap'), and two small groups of barns come into view almost directly ahead — the *majadas* of La Llama and La Cerezal. Follow the track as it contours around to the left, until you reach a natural spring discharging into an old stone water trough, the Vao de Los Lobos (**2h35min**).

From here, follow the main walk from the 1h25min-point, to the Jito de Escarandi, via the Picos de Macondiú. From Escarandi, you complete the circuit by following the main walk from the start to the 1h25min-point, returning to the Vao de los Lobos after about **7h15min** walking. You must then retrace your steps back down the zigzags to Beges, enjoying the superb view from a different direction (**8h50min**). You can telephone for a taxi at the Mesón San Carlos.

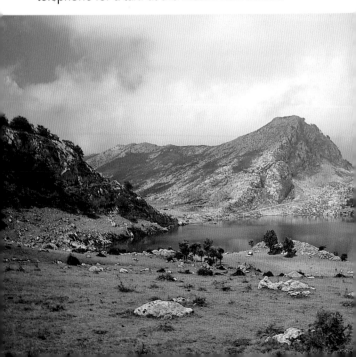

Map pages 120-121; another photograph pages 122-123

Distance: 4km/2.5mi; 1h35min

Grade: a short, easy walk, with an ascent of around 100m/330ft near the end. Be warned that during the summer and at weekends the lakes attract large numbers of visitors, as they are the focal point for tourism in the Covadonga National Park. Often impassable from November to May.

Equipment: stout shoes, sunhat, cardigan, raingear, picnic, water

How to get there and return: 🚌 ALSA (Tel. 98-584 81 33), from Cangas de Onís to Los Lagos de Covadonga (summer only); journey time from Cangas about 1h30min. Or 🚗: park by Lago de la Ercina, at the end of the road which connects Covadonga with the glacial lakes.

A lthough short, this excursion is scenically very beautiful, taking in both of the glacial lakes in the Covadonga National Park. Its main advantage is that within a relatively short distance you can escape from the crowds that congregate around the lakes, and experience the region from a shepherd's point of view.

The walk begins at the car park by Lago de la Ercina. Follow the right-hand margin of the lake, choosing your own route across the springy turf that is studded with hoop-petticoat daffodils, dog's tooth violets and gentians in spring and the delicate six-pointed stars of merendera in late summer. The surface of the lake

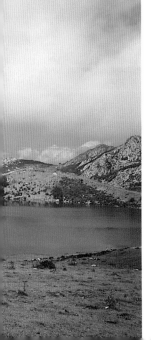

Left: Lago Enol from the south. The road in the background leads to Lago de la Ercina. Below: Linaria faucicola, a toadflax endemic to the Picos de Europa, has purple flowers shaped like miniature snapdragons.

usually hosts a scattering of noisy coot and mallard, while the limestone boulders which sprout from the pasture provide a foothold for species such as livelong saxifrage, fairy foxglove and *Linaria faucicola,* the Picos de Europa's endemic toadflax shown on page 113.

After about five minutes, you pass a stone water trough and spring on the right, and a few minutes later you come across a wide trail descending from the Refugio Entrelagos up on the right, which you follow southwards as it squeezes between the sheer wall of Pico del Mosquital (see photograph pages 122-123) and the lake. Almost immediately the trail forks: both branches lead to a small cluster of *majadas* known as Las Reblagas, occupied by shepherds looking after their cows and sheep and preparing artisan cheeses during the summer months. The right-hand fork is a well-marked trail (easily followed) which climbs gradually up away from the lake under Pico del Mosquital, passing a barn built into the cliff en route, but the left-hand branch — little more than a path — is the more scenic route.

Following the left-hand fork, continue along the edge of the lake until you reach the retaining wall at the southern end (**15min**). The most obvious path at this point turns left and follows the top of this dam, but take instead the narrow path which goes straight ahead: a short, steep climb takes you through a limestone rock garden up towards Las Reblagas. In late summer, look out for the tall, purple flower-spikes of monkshood, also known as wolfsbane. Although a highly poisonous plant to humans and livestock alike, this species is also the source of one of our most useful drugs — aconitine — which is utilised to diminish the pain of neuralgia, lumbago and rheumatism.

By **20min** you will have arrived at the low wall surrounding the first *majada*, which you must leave on your left, veering right to rejoin the main trail coming up from the right; here you turn left and pass the remaining *majadas* in Las Reblagas. Follow this trail to the right around the hillside, ignoring a braided path which splits off between two limestone outcrops on the left. Your trail soon becomes little more than a path itself. Ahead, the low-lying marshy depression backed by limestone crags, with beech trees clinging to the almost sheer walls, is the Vega Bricial.

Keep following the path, leaving the Vega Bricial down on your left, which leads you down through large

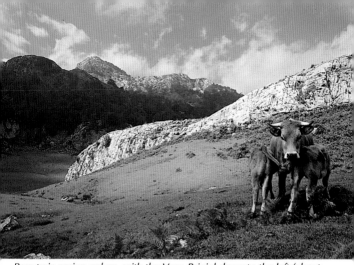

Rare twin casina *calves, with the Vega Bricial down to the left (about 25min into the walk)*

blocks of limestone to a group of *majadas* called El Bricial, huddled in the shade of an ash grove (**25min**). The large National Park information board in the midst of the buildings describes the origin of the Vega Bricial. From the sign you head down left into the Vega itself, which in the summer is home to a herd of *casina* cows: these small, tan-coloured cattle (see above), with sharp, pitchfork-shaped horns, are the native race in the high mountains of Asturias. If the base of the Vega is very wet, skirt around its right-hand edge. Typical wetland plants occupy the floor of the hollow, including sphagnum mosses, horsetails, whorled caraway and marsh ragwort.

Head towards the sheer cliff at the back of the Vega, which is adorned with gnarled beech trees, clinging to it at impossible angles. When almost at the foot of this wall, turn right and head up a short gully towards a gap between two outcrops of limestone, via a 3m-wide strip of trampled rock garden, edged with warped beeches emerging directly from the living rock. A yellow-flowered and equally toxic species of monkshood — *Aconitum lamarckii* — grows here. The view of Vega Bricial behind you is stunning from this point.

By **35min** you come to the top of the gully, marked by a collapsed dry stone wall across your route. The continuation of your path runs straight ahead, although in high summer it may not be very obvious because of the height of the bracken. If in any doubt, stay on the ridge which separates two shallow gullies, and about

30m/yds from the col you will easily encounter the path: it runs across limestone pavement, which is worn smooth by the passage of many feet, both human and bovine, over hundreds of years.

This path — known locally as Cuenye La Jelguera — leads you off the low ridge and down into the gully on your left, where it becomes wide and grassy before briefly disappearing into the bracken again. Ahead of you is a patch of beech forest, which you keep to your left, as you skirt it on a rocky path. The surrounding limestone rock gardens are thick with the yellow flowers of *Sideritis hyssopifolia*, called *té de roca* ('rock tea'). The local people collect it to make a digestive and calming infusion.

Having traversed another area of bracken and rough pasture, at **45min** you join an eroded earthen path coming in from the right: turn left here, and almost immediately cross a stream. From here on the path is often braided, running down a shallow valley with the limestone bulk of Pico del Mosquital up on your right. The path is alternately a trail-like route across limestone outcrops and a narrow earthen path through grassland and bracken.

At about **50min** the wide vehicle track which connects Lago Enol with the Mirador del Rey comes into view ahead, and the outlook widens to include the velvet-like alpine pastures of the Vega de Enol, scattered with groups of *majadas*, generally in the shelter of half a dozen lollipop-shaped ash trees (these trees, shown on page 55, are lopped and topped every two years; the leaves are fed to the livestock in the autumn and the poles are used as kindling, for supporting runner beans or for fencing). On the far side of the track lies the Refugio Cabaña de Pastores — a rather unattractive 'mountain' refuge with a restaurant and bar.

Your path swings to the right, leaving a tiny stone chapel on the left and, at **55min**, without joining the vehicle track, it leads you to a large *majada* and a small outbuilding under the obligatory ash grove, this time accompanied by a solitary beech tree. Here you are exactly opposite the refuge, the adjacent free-camping area and a small car park.

From the *majada*, follow a faint grassy path along the edge of the Vega de Enol, with the limestone outcrop immediately on your right: you are walking parallel with the vehicle track on your left, but at some distance from

it. Keep an eye out for such typical upland birds as wheatears, water pipits and alpine choughs. In a very short time, Lago Enol comes into view ahead.

You arrive at the southern edge of the lake at **1h05min**: turn right along the shore, on a narrow rocky path. The water is very clear — and tempting on a hot day — but swimming unfortunately is not permitted. The path leads you under a large overhang on the very edge of the lake: a rocky trail has been laid in the water so that you don't get wet feet! The flora on the limestone here is very diverse, including leafless-stemmed globularia, alpine lady's mantle, the woolly-leaved *Hieracium mixtum*, fringed pink and large-flowered butterwort.

Having passed under the overhang, the path winds up away from the lake somewhat, passing through short, springy turf and limestone outcrops. Majada La Piedra lies over on your left, on a verdant lakeside plateau, ringed with lopped-and-topped ashes. The path eventually leads you out onto the grassy plateau of La Piedra (**1h10min**), but instead of heading left, towards the barns, keep to the right-hand side of the grassy area and head uphill, making for a solitary building silhouetted on the ridge ahead.

Having climbed about 20m/yds up from the level of La Piedra, you find yourself on a gentle grassy slope, from where you can see a path climbing to the top of the ridge, diagonally up to the left, leaving the lone building well to the right. This is the continuation of your route, so cross the grassy *vega* in front of you, making for the bottom of this path.

It is quite a hike up the braided earthen path to the top of the ridge, known locally as La Picota, but the superb view of Lago Enol behind gives you an excuse to pause for breath now and again. You reach the top of the ridge at **1h30min**, almost exactly above the Refugio Entrelagos — another rather unsightly bar/restaurant, but more than compensated for by the panorama of high peaks to the east, behind the Lago de la Ercina.

Having encountered a track running along the top of the ridge, head directly down towards the refuge. Cross the road which leads up to the refuge from the left, and go round to the front (far side) of the building, from where a wide, eroded path zigzags down to the car park where you started the walk (**1h35min**).

11 LAGO DE LA ERCINA • MAJADA DE LAS BOBIAS • LLAGUIELLU • COLLADO EL JITO • VEGA DE ARIO • MAJADA DE BELBÍN • LAGO DE LA ERCINA

Map pages 120-121

Distance: 16km/10mi; 5h35min

Grade: Moderate, with a climb of about 550m/1805ft up to the Vega de Ario, followed by a descent of the same, but via a different route. This is not a walk to attempt in bad weather, as you could easily stray off the path under conditions of poor visibility, but there is no danger of vertigo at any point. Virtually the whole route may be under snow between November and May.

Equipment: walking boots, sunhat, thick cardigan, raingear, picnic, water, compass, whistle

How to get there and return: 🚐 ALSA (Tel. 98-584 81 33), from Cangas de Onís to Los Lagos de Covadonga (summer only); journey time from Cangas about 1h30min. Or 🚗: park by Lago de la Ercina, at the end of the road which connects Covadonga with the glacial lakes.

Short walk: Lago de la Ercina — Majada de las Bobias — Majada de Belbín — Lago de la Ercina: 7.5km/4.7mi; 2h20min. Easy; access, equipment and season as above, although stout shoes will suffice. Follow the main walk to the 1h-point, then pick it up again from the 4h15min-point, although you will turn *left* at the 1h-point, rather than right.

This route takes you into the heart of the western massif of the Picos de Europa, through some of the most impressive areas of limestone pavement in the whole range, with an alpine flora to match. The climb is well worth the effort, as the view of the peaks of Urrieles is magnificent from the Vega de Ario.

Start out from car park at Lago de la Ercina, and follow the well-worn path across the turf which circles the left-hand margin of the lake. Ahead, about halfway down the eastern side of the lake, you can see the beginning of the path up to Ario. It cuts across the foot of the limestone crag which is a westerly extension of Pico Llucia. En route to the crag, you pass a sign with a map of the Covadonga National Park.

In just under **10min**, you arrive at the start of this path, exchanging springy pasture underfoot for gravel-strewn limestone. Veer left around the side of the crag and, a few minutes later, pass a couple of barns and an ash grove on the left, sheltering in the lee of the cliff. The path climbs gently as it winds through the limestone outcrops and pasture and, at about **15min**, you pass another barn on the left.

Down on your right lies the broad grassy valley which holds the Riega El Brazu — one of the streams that feeds the lake. Looking back across La Ercina, you

can see the *majada* called Las Reblagas (visited on Walk 10), nestling at the foot of Pico del Mosquital, whose bulk is reflected in the lake's surface (photograph pages 122-123).

Shortly you leave the limestone behind, to traverse an area of heathland, populated with St Dabeoc's, Cornish and cross-leaved heaths, gorse and ling. This section of the path can be very muddy during snow-melt or after heavy rain. The Riega El Brazu is immediately on your right now; although often dry in mid-summer, in spring it is a mass of marsh marigolds (photograph page 78) and large-flowered butterworts (photograph page 125). The main part of the Riega heads off to the right, but the path follows one of its tributaries for a time.

By **30min** you are back in limestone country again, crevices in the bare rock supporting clumps of livelong saxifrage, Pyrenean germander and fringed pink, as well as a pink-purple relative of the toadflaxes called *Chaenorhinum origanifolium*. Ten minutes later, you have a short but steep ascent through a limestone outcrop, after which the path levels out and you are back in gorse heath again, on a plateau. The path drops slightly as you traverse the ridge called Cuenye Las Bobias, passing above a deep circular hollow down on the left, followed by an even bigger one on the right: these smooth-sided depressions are known as *hoyos* in Spanish, but locally as *jous*. Ignore the small path off to the left just before the second hollow, beyond which your path starts to descend slightly, and bends round to the right, leaving a limestone-capped hill on the left. You pass a couple of fenced-in groves of beech trees on the limestone on your right, and then a large, cliff-backed depression containing pasture and limestone pavement, also down on the right, where sparse beech forest clings to the crags.

If you look ahead at this point, you might be unfortunate enough to spot the steepest ascent on this walk: a series of zigzags known as Las Reblagas. (The reddish-brown scars, visible even at this distance, have been caused by walkers taking short cuts and eroding the pasture.)

The path descends yet further before leading you into the Majada de las Bobias in just under an hour's walking. A handful of single-pitched, pantile-roofed *majadas* are scattered across the gentle grassy slope. While some are for animals, others are obviously inhabited by man,

at least in the summer. Your path runs through the middle of these *majadas*, still descending, until you reach a flat-topped, dais-like rock in the middle of the path (**1h**). A water-trough fed by a crystal-clear spring is built into its left-hand side. *Here the Short walk turns left* (and the main walk turns right on the descent from the Vega de Ario). ***Important:*** *Those doing the Short walk should turn now to the 4h15min-point in the main walk* (page 124) *and read the caution about the descent via the Majada de Belbín; this descent is not recommended in mist.*

After the 'dais', your path zigzags steeply up through a limestone outcrop, sparsely populated with twisted beeches. Crested tits are common here, and you might be lucky enough to spot citril finches too. Yellow splashes of paint — which are to accompany you all the way to Ario — appear for the first time. A few minutes later, the path levels out and starts to descend across limestone pavement towards the Llaguiellu grassland and Las Reblagas. Cushions of yellow mountain saxifrage appear on spring lines in the rock. The path braids here, and although all routes lead to Llaguiellu, the

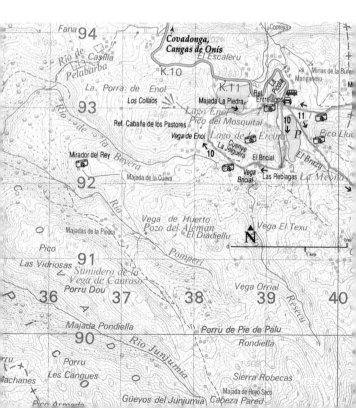

upper, right-hand path is by far the easiest option (the lower path is starting to collapse down into the valley down on the left). From this point, you will be relieved to note that the zigzags of Las Reblagas don't look quite as impossible as before! The *majada* visible down on your left is La Redondiella, which you will pass on the return route.

At **1h15min**, you arrive at Llaguiellu, a tiny wet *vega* to the right of the path, with an exit stream (populated by leeches and tadpoles) which crosses your path at the foot of Las Reblagas. Ignore a small path heading up to the right of Las Reblagas, and take the main path which zigzags up this tremendously scarred slope. Although the climb is only about 100m, it is very steep: there is still a long way to go, so take it easy here, and follow the yellow paint marks so as to avoid eroding the slope any further.

After what seems like an eternity, but is in fact only about twenty minutes, you reach the top of Las Reblagas (**1h35min**). Here the surrounding landscape is more bleak: the trees have all but disappeared, and the wide expanses of pale limestone are sprinkled with green-

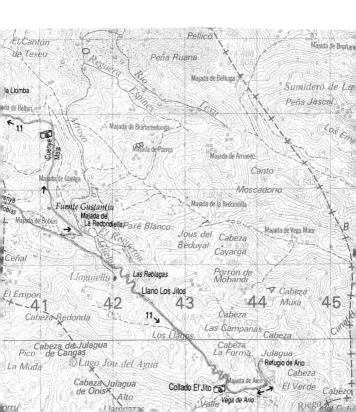

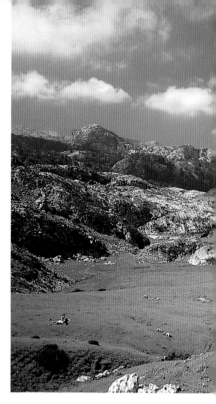

Near the start of the walk, Pico del Mosquital rises behind Lago de la Ercina. The verdant pastures in the foreground support large herds of cattle and horses in the summer, leaving the lower-level meadows free to produce the harvest and hay which maintains these animals in winter.

weeds, heathers, tiny alpine herbs and goats. Your path now undulates up to Llano Los Jitos: the col that you can see on the skyline, slightly to the right. The path is easy to follow, and is still marked with yellow paint.

You reach Llano Los Jitos at **1h55min**, appropriately marked by a cairn (*jito* is Asturian for the Spanish word *hito*, meaning 'boundary post', or 'milestone'). From here you descend slightly before tackling a less strenuous, but longer ascent towards the Collado El Jito, visible from far below on account of its twin cairns, which stand out clearly on the horizon. You pass through an area of spectacular limestone pavement, populated by typical high mountain plants such as western St John's wort, Cantabrican bellflower, mountain sanicle, moss campion (see photograph page 104), alpine gypsophila, round-headed rampion and matted globularia. Look out too for alpine accentors, black redstarts and snow finches foraging among the rocks.

After a fairly steep pull up a series of wide zigzags, you finally emerge onto the Collado El Jito (**2h45min**). (Just before the col, a sign painted on the rock indicates that the Refugio de Ario is a mere 15 minutes away.)

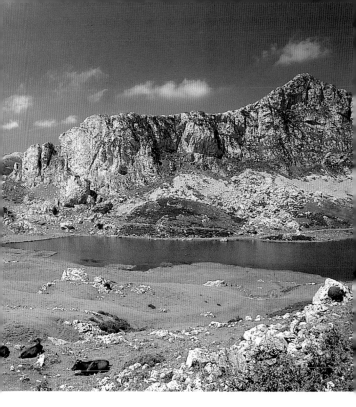

Once at the top, the path is more or less level, leading you to a short cylindrical pillar, the top of which is engraved with a diagram indicating all the major peaks of the central massif which are visible from this point. This is undoubtedly one of the best views in the Picos de Europa, although often obscured by mist or cloud.

From here the path drops slightly and curves to the left through the limestone rock gardens on the top of the plateau. The peak of Cabeza La Forma (1717m/5630ft) stands out on your left, and you pass some ruined barns on the edge of the path. Although the route is not always obvious, the paint-marks relieve you of any doubt. The green, velvet-like pastures of the Vega de Ario lie over to the right, with a large number of barns (Majada de Aico) on the far side; most of them are roofless today. The Refugio de Ario (1630m/5350ft), also known as the Refugio del Marqués de Villaviciosa, in memory of the gentleman who was instrumental in the founding of the National Park, soon comes into view, and you arrive at **3h**. There is a spring just to the left of the refuge, and canned drinks are on sale inside.

Having made the effort to get here, it is certainly

worth having a wander around the Vega de Ario, before returning by the same route until you reach the 1h-point of the ascent — the water trough in the dais-like rock (**4h15min**). At this point you will have to decide whether to continue back to Lago de la Ercina by the outgoing route (a total walking time of 5h15min), or to complete the circuit via the Majada de Belbín. Very often an afternoon mist builds up in this part of the Picos de Europa: *if this is the case, do not attempt the Belbín option, as it is extremely easy to get lost there.*

Turn right at the 'dais' *(left if approaching from Majada de las Bobias, for the Short walk),* descending the left-hand side of a grassy gully. The small path soon bends round to the right and cuts across a limestone outcrop punctuated with scattered beech trees. At the end of the limestone, you emerge onto a small grassy area, with a short cliff on the right (**4h20min**). The path continues straight out of the other side of the grassy area, to the left of a largish boulder, and cuts down the hill towards a group of mostly-ruined barns; you can just see the roof of one still-functional *majada* (topped by a solar panel!) tucked in under the cliff immediately below you. (There are also two barns over to your left, on the other side of the valley — the Majada de la Redondiella.)

Before actually reaching the building with the solar panel, bear left down towards the floor of the valley, descending a grassy slope (there is no real path here). Just before the bottom of the valley, turn left again, curving back below the way you have just come. The Majada de la Redondiella is now on your right, as is the floor of the valley. The path is now fairly obvious, passing through limestone rock garden and pasture with some patches of heath. Always keep the floor of the valley on the right; the river only flows in winter.

At **4h30min** come to a water trough on your left — the spring is known as Fuente Gustantiu — and keep going straight ahead, well above the bottom of the valley. The valley then veers sharply to the right, but you carry straight on in your original direction, following the path.

Cross a grassy plateau at **4h35min**, then follow the path as it ascends the left-hand edge of a prominent limestone outcrop. This very short climb leads you to another grassy plateau, where you are confronted by three smaller limestone outcrops: go between the right-

Pinguicula grandiflora, *the large-flowered butterwort is commonly seen on Walks 5, 9, 10 and 11.*

hand one and the middle one, over the col and down the grassy tongue on the other side. From here it is easy to see your continuation — the route traverses diagonally up the slope ahead. A couple of minutes down from the col, a shallow valley veers off to the right, but your path carries on dropping slightly, before reaching the foot of the diagonal traverse at **4h40min**.

A gentle climb follows, up this well-worn earthen path, through heath pasture with some bracken. Far below on the right you can see a small group of barns on a verdant *vega* — the Majada de la Güelga. The path braids slightly as you near the crest of the hill. At **4h45min** you reach the top and the path becomes more trail-like; it is known locally as the Cuenye Mala. It drops slightly, goes over another col and then contours round the side of the hill towards the Majada de Belbín. A couple of bigger tracks are visible down in the valley to your right, but keep to the same path, and maintain your height. A spectacular panorama across the mountains to the northeast opens up at this point.

Five minutes later you reach the crest of a spur running to the east of the Majada de Belbín, which is clearly visible below you in a wide grassy depression, slightly to the left. You can also see the track running west out of the other side of the hollow, which is the continuation of your route. Cut down to the left on a small path towards the group of *majadas*, then cross the

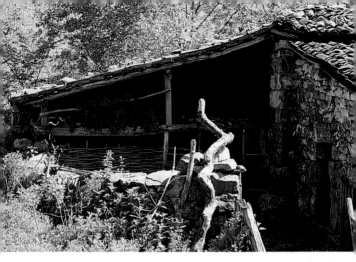

Thick stone walls and gently-sloping pantiled roofs are typical of the vernacular architecture of the Picos de Europa. Wide overhangs provide shelter for the drying of maize (fed to cattle) and beans. (Photograph taken on Short walk 3 for motorists.)

depression, leaving Belbín on your right. Sheep and cows graze peacefully on the floor of the hollow; their milk will be made into artisan cheeses by the summer inhabitants of the *majadas*.

You reach the foot of the track at about **5h**, then follow it as it zigzags up the hill. At the *second* right-hand bend in the track (at about **5h20min**), from a grassy plateau, you can see the Majada de la Llomba over to the right, on the main track. Your route, however, is a small path that forks off left (more or less straight ahead) from this right-hand bend in the track. Keep on the same level, and contour along below Pico Llucia (the outcrop of limestone on your left), following one of the many cattle paths. You head towards the ridge directly in front of you. Griffon and Egyptian vultures are a common sight here, soaring on outstretched wings in search of carrion. En route you will have to cross several small gullies heading down into the valley on your right; some of them contain streams.

You reach the top of the ridge at **5h30min**, to find yourself overlooking Lago de la Ercina once more. Head down the grassy slope towards the car park, arriving after **5h35min** walking.

Index

Geographical names comprise the only entries in this index. For other entries, see Contents, page 3. A page number in **bold type** indicates a photograph; a page number in *italic type* indicates a map. Both may be in addition to a text reference on the same page.